Judith Collins

CECIL COLLINS

A Retrospective Exhibition

The Tate Gallery

front cover
Head of a Fool 1949
cat. no. 121

back cover
The Artist and his Wife 1939
cat. no. 15

frontispiece
Cecil Collins 1989

Photographic credits: James Austin, David Cranswick,
City of Derby Museums and Art Gallery, Clive Hicks, Colin Jeffrey,
Anthony d'Offay Gallery, Peter Nahum Gallery, Jonathan Stedall,
V & A Picture Library, Andrew Watson and Witt Library

ISBN 1 85437 017 0 (paper)
ISBN 1 85437 022 7 (cloth)
Published by order of the Trustees 1989
for the exhibition of 10 May–9 July 1989
Copyright © 1989 The Tate Gallery All rights reserved
Designed by Caroline Johnston
Published by Tate Gallery Publications, Millbank, London SW1P 4RG
Typeset in Sabon and printed on Parilux matt 150 gsm by
Balding + Mansell UK Limited, Wisbech, Cambs

Contents

Artists can do something more:
they can vanquish the lie.

Alexander Solzhenitsyn

Foreword

Cecil Collins, now aged eighty-one, has consistently and with dedication pursued a singular path through the past six decades of twentieth century British art. A mid-career retrospective was shown at the Whitechapel Art Gallery in 1959, so thirty years have elapsed since the full sweep of his work has been seen, however Collins has had a profound influence on several generations of students through his teaching at the Central School of Art. If the public respond to the advent of the millennium of 2000 as they did when facing the year 1000, rushing up mountain tops armed with provisions and blankets awaiting the apocalypse, then we are in need of the optimistic message which Collins's paintings and drawings offer. He makes his paintings and drawings as objects for contemplation; for his subject matter he employs archetypal images such as the Fool and the Angel, which strike resonances in us all. His message is basically one which stresses the importance of love in our lives, and all his experiments with colour, tone, form and content have been to guide us to that realisation.

My colleague in the modern collection, Judith Collins, who selected and catalogued the exhibition, has worked closely with the artist, and the circle of writers, poets and musicians who are his friends and admirers, and her thanks are offered overleaf. We are also very grateful to all the lenders, both named and anonymous, who have parted with treasured works for this exhibition. Every one of them agreed to lend with alacrity, even though they faced the prospect of an empty wall for several months, because they wished to share their works with a larger public. We are also pleased to collaborate with Southampton Art Gallery, who will be taking a slightly smaller version of the exhibition after its showing at the Tate Gallery.

Nicholas Serota *Director*

Acknowledgments

Shortly after joining the Tate Gallery I was taken by Richard Morphet, Keeper in the Modern Collection, to tea with Cecil and Elisabeth Collins. I now see that this was the first step in the curating of this exhibition. During tea Cecil and I ascertained that as far as we could tell we were not related. Since then I have taken many teas with Cecil and Elisabeth Collins, which have helped greatly to extend my knowledge of his life and his work, and incidentally to extend the circumference of my waistline. It is an understatement to say how deeply indebted I am to them both. I have been particularly impressed by the invigorating openness of mind to new artistic stimuli which is shown by these two people who are both over eighty. For other most useful information, assistance and hospitality I wish to thank William Anderson, the author of the first full-length monograph on Collins which was published last year, Maureen Attrill, Robin and Ann Baring, Dr Mary Beal, Terry Charman, David Cranswick, Marilyn Donovan, Bernie Gregory, Clive Hicks, John Lane, Dr David Mellor, Richard Morphet, Peter Nahum, Mary Bride Nicholson, Robin Orr, Dr Dimitris Papastamos, Alex Robertson, Bryan Robertson, Ann Simpson, Willi Soukop, Rosamund Strode, Robin Vousden and Canon Keith Walker.

The Art of Cecil Collins

Cecil Collins makes both paintings and drawings and they exist independently of each other. He does not make drawings in preparation for a painting, they exist as finished products. Exceptionally there is just one picture in his oeuvre for which preparatory studies were made and that is the double portrait of 'The Artist and his Wife' (cat.no.15). If a chronology has to be extracted, then drawing with line and tone as an activity came before painting in colour because this was the way his artistic training proceeded.

More than half the works in this exhibition are drawings and they testify to the importance of this activity for him. He still teaches drawing to this day. Collins is interested in the etymology of words (it links in with his fascination with the origin of things, eg. the universe, mankind, light and dark and like matters) and he likes the fact that the word 'draw' is used of drawing breath, of inspiration, of drawing a curtain, thus concealing and revealing, and to draw a person out, to get to the essence of someone.

Most of his paintings and drawings take a long time to execute, the exception being the 'matrical' works of the late 1950s and early 1960s, and Collins acknowledges that he does not actually like working. 'Only bad painters enjoy painting' he says. He has had to endure unproductive periods; for painting it was the mid 1940s and some years in the 1970s and 80s and for drawing the late 1950s, 60s and early 70s. He has adopted a pattern of work that fits his seemingly frail physical frame. He seldom works in the morning and finds that most 'real' work is done between five and seven-thirty, with his brain and hand becoming very clear by nightfall. He is usually sad at dusk, at the going down of the light. He says he sets his face to the dawn, to the rising of the light, although he does not work early in the morning. 'I know about dawn without having to be there'.

Collins's first exhibited painting is believed to be one submitted in 1926 to a mixed exhibition in his home town of Plymouth. The painting no longer exists, and his memory of it is that of a group of muscular men. It was probably an imaginative work, drawing on lessons learnt in life classes at the art school and executed with a knowledge of the work of Frank Brangwyn, an artist whom he then admired. In 1928 while a student at the Royal College of Art he submitted a portrait of a woman 'Stella' and a sculpture of a New Testament theme to a student exhibition in the Victoria and Albert Museum. Again both these works are lost, and the artist cannot recall the nature of his only three-dimensional work. But the subject of the sculpture, the Deposition, is significant. He was obviously not prepared to experiment with form without charging the form with meaning, and meaning of a deep and universal significance. Collins studied in his own time while at the Royal College of Art the painted works of the Italian Renaissance masters in the collection of the National Gallery, and the three-dimensional works of medieval and Italian sculpture at the V&A. He describes the cast courts of medieval and Italian sculpture at the V&A as 'a landscape of dreams'. Works of these periods concern themselves predominantly or even exclusively with Christian themes and it is not too surprising to find an admiring student producing his own work with a New Testament theme. Biblical themes were considered by art school tutors to be very suitable subjects for imaginative compositions, and one of the subjects given to Royal College students for their diploma work in Collins's final year was the Old Testament theme of 'Ruth amid the Alien Corn'. A very rudimentary and simple classification of the different moods of the Old and New Testaments could be distilled as one of judgment and vengeance for the former and love and compassion for the latter. Most portrayals of the Deposition concentrate upon the figures which support the body of Christ and show them turning to him and holding him in various aspects of love. One could postulate, with hindsight, that Collins's portrayal followed this path.

Collins was not to portray overtly New Testament/Christian themes in his art again after 1928 until *circa* 1952, but the theme of love begins to occur in a covert manner in his work *circa* 1934 when, joyful in his newly married life with a talented and beautiful fellow student Elisabeth and confident in his own technical, formal, intuitive and intellectual abilities, he begins to find his own way of presenting such a fundamental emotion of human existence as love. The extant paintings of his student and

immediate post student years, those up to 1933, reveal a young artist finding his own way. There are a very small number of subjects that would have warmed the heart of Roger Fry, portraits and still lifes concentrating on flowers, to indicate that Collins passed through a short period of experimentation with significant form. However, painting which stresses the significance of form does so to the detriment of the subject matter and Collins realised he was not prepared to compromise in the presentation of his subjects or themes. As he writes 'If painting is merely a process and nothing but an arrangement of colours, forms and textures for their own sake, then the artist becomes a mere manufacturer of visual confectionery.'

The earliest major painting from this period still extant is 'Maternity', (cat.no.1) a work which still surprises the viewer. Collins acknowledges some influence from Rembrandt in the handling of the subject, but the image, a heavily pregnant nude woman, is his own. It was found to be too controversial in subject matter and presentation to be included in an exhibition of Royal College of Art students' work held at the V&A in 1930 and it remained unexhibited until Collins's retrospective at the Whitechapel in 1959. Although no influence is implied, Collins's 'Maternity' stands in relation to the rest of his career as Jacob Epstein's 1910–12 unfinished stone carving 'Maternity' does to his. Epstein's 'Maternity' announced his interest in the themes of fertility and procreation, both human and animal, which he treated in a variety of ways in the following decades. A further representation in stone of a pregnant woman, 'Genesis', was begun by Epstein in 1929, the year that Collins painted 'Maternity'.

Collins's 'Maternity' has an inscription on the back of the support which reads 'Forebeare/Mother of Man/Wither'. The words 'Forbeare' (which can mean ancestor) and 'Mother of Man' indicate an identification of this woman with a symbolic female figure from whom mankind is descended, in other words, Eve. The word 'Wither' could mean that which will decay or it may be a mis-spelling of Whither (Collins cannot recall the source of the inscription) and if the latter, then the inscription may take the form of an interrogation; to what place or to what point is the future of mankind destined? Collins's serene, tender and voluptuous mother could thus be read as a symbol for his burgeoning interest in presenting in visual form the fate of humanity.

If Collins's 'Maternity' can be tentatively identified with Eve, then her first pregnancy took place outside of Paradise, and after mankind's disobedience against God. Having unlawfully tasted of the fruit of the Tree of the Knowledge of Good and Evil, she initiated mankind's expulsion from the Garden of Eden. Because 'Maternity' is so arresting

and immediate as a formal image, the deeper implications of her message are masked. The large canvas of 'The Fall of Lucifer' (cat.no.4), marks the arrival of Collins's maturity as an artist and announces with intensity and clarity the major theme he offers repeatedly in his works, that of the loss of Paradise. The choice of this subject, the fall of Lucifer, was very astute because theologically and philosophically it is seen to precede Adam and Eve's expulsion from the Garden of Eden, the more usual way of presenting visually the loss of Paradise. Representations of the scene of the fall of Lucifer are quite rare in visual art, mainly because the subject has no straightforward Biblical text. The earliest illustrations of the story are to be found in Anglo-Saxon illuminated manuscripts of the early eleventh century. (Junius II in the Bodleian Library and Cotton Claudius B IV in the British Library). The literary basis for the myth of the rebel angels is complex. The writers of the Apocryphal books of Jubilees and Enoch (2nd–1st centuries BC), speculating on the union of the sons or angels of God with the daughters of men found in Genesis, 6, 1–5, expand the narrative with a description of the fall of angels, whose leader was God's adversary. This extra-biblical myth had been absorbed into Christian literature by the 2nd century AD. Theologians then spent much thought attempting to establish the exact point when Lucifer and his angels fell. Job, 38, 4–7 was produced as evidence for placing the creation of the sons or angels of God (male theologians obviously see these creatures as male!) before the beginning of the creation of the earth – 'Where wast thou when I laid the foundations of the earth? … When the morning stars sang together, and all the sons of God shouted for joy?' On the stiffer problem of when the angels fell from grace, St Augustine produced an answer in Chapter 19 of book XI of his *De Civitate Dei*. He declared that the fall of the rebel angels occurred on the first day of Creation and represented their fall as a symbolic separation of the darkness from the light. St Augustine does not mention the name of Lucifer for their leader. The biblical passage which gives the name of Lucifer is Isaiah, 14, 12, 'How art thou fallen from Heaven, O Lucifer, son of the morning,' and Jesus's words (Luke 10, 18) 'I beheld Satan as lightning fall from Heaven', are seen as a New Testament gloss on the passage from Isaiah. A further biblical reference pertinent to the myth of the fall of the angels occurs in the book of Revelation, 12, 7–9, describing a war in Heaven between two angelic armies, led respectively by the archangel Michael and Satan.

Nearly all medieval representations of the scene of the fall of Lucifer, most notably in manuscript illuminations, show the event divided into horizontal divisions, with Satan plunging into a fiery hellmouth at the very bottom. Collins's representation conforms to the earlier versions with its

rich layers of action, but significantly there is no hellmouth nor any sign of a place of condemnation and misery. Instead, at the bottom of Collins's tall canvas, there is a rhythmic composition of warring angels, some winged, most wielding swords, and some wearing a goodly combination of eccentric heavenly vestments. The alternative title for 'The Fall of Lucifer', the one Collins inscribed on the back of the canvas is 'The Holy War' and it is this aspect which dominates the composition. Hell is not given a visual counterpart in Collins's imagery, not in 1933 and equally not in 1989. It is something he can envisage in his imagination, but his artistic temperament prevents him from giving it visual form.

Collins's large canvas took him several months to paint, it was done for no outward purpose and was most unlikely to find a buyer. It is impossible to imagine another young British artist in the early 1930s undertaking such a subject, although its secondary subject of the Holy War could well be seen as a detached and veiled reference to the various ideologies in conflict at the time, in Spain, in Germany and in Russia. A painting (whereabouts unknown) which Collins exhibited at Dartington Hall in 1937 was entitled 'The Transformation of Hell', recorded as painted in 1934, although the artist remembers that it was painted close in time to 'The Fall of Lucifer'. He recalls the composition having a black grid through which flames were visible and above which the souls of the dead rose. Another painting pertinent to these two is one entitled 'Resurrection' 1934 (whereabouts unknown), shown at the Bloomsbury Gallery in 1935, whose title would lead one to assume that it presented an image of the rising of one particular soul, that of Christ, or more likely, given Collins's independent attitude towards biblical illustration, the restoration of a new kind of consciousness to a generalised group of souls. In 1935, 'Resurrection' and 'The Fall of Lucifer' were shown at the Bloomsbury Gallery alongside a work called 'History of a Butterfly', 1934 (again whereabouts unknown). Collins has used the symbolism of the butterfly in several works since 1934 evoking the path of the soul. The butterfly passes through three stages, the active, mundane caterpillar, the dormant carapaced chrysalis, and the brightly coloured winged butterfly, which rises from the earth's surface. This is an insect version of what happened to Christ. In a painting which Collins was invited to exhibit in the International Surrealist Exhibition of 1936, entitled 'Virgin Images in the Magical Processes of Time' (cat.no.9), the artist painted the word Resurrection eleven times in red capital letters on a large amoeboid form. The discovery of this mantra-like inscription with its spiritual connotations caused a split between Collins and the Surrealists.

Collins spent the period of 1933 to 1936 working both in London and at

Monk's Cottage, Highwood Bottom, near Speen in Buckinghamshire, with the London address gradually given up in favour of the country one. Monk's Cottage was the second of four cottages set out at intervals along a bridleway which branched off the main road to Speen and ended at a dark wood. The country cottage, with no gas, electricity or water (not an easy life for an artist's wife who had to provide the meals), was rented for ten shillings a week from an actor called Mr Monk, hence its appellation by the Collinses. However, since Peter Levi describes a monk's life as one lived on 'the frontiers of Paradise', and since Collins's period at Highwood Bottom was one of great silence, peace, introspection, frugality with money, and the repeated readings of mystical texts, it is not far fetched to see the name of the cottage as indicative of the atmosphere there. (Collins's beard grew to its most hirsute proportions at Highwood Bottom.) At Monk's Cottage, and at Springhill (another symbolic name?), the next house taken in the hamlet of Highwood Bottom, Collins read the poetical works of Thomas Traherne (1637–1674) and Henry Vaughan (1622–1695), and the mystical works of Jacob Boehme (1575–1624) and Meister Eckhart (c.1260–1327/8), among others. Both Traherne and Vaughan were 17th century British writers of religious verse and prose of marked originality. Traherne felt that he came to know God through a delight in his created world, and his writings express simplicity, love, innocence and happiness. Vaughan's most famous religious poem begins 'They are all gone into the world of light', and he believed that man is a pilgrim who, holding the memory of paradise within him, wishes to regain it. Vaughan's symbol for the paradise man has lost was light and Vaughan believed that man has a spark of this Divine Light burning in the darkness of his everyday life. Boehme was a German mystic who offered a symbolic interpretation of light and dark as powers of Good and Evil, of God and Satan (Lucifer). His first tract was entitled 'Dawn Glow' (a book still in Collins's library today). Eckhart describes how man must be still, and the mind must be emptied and made dark in order to contemplate the mystery of the Divine. The paintings executed in the quiet countryside of Buckinghamshire (cat.nos.6–11) lay out for the viewer the main themes of Collins's career; all the works that follow, however different they might look, are explorations of the seminal ideas sown in the years 1933–6.

Collins had begun his country cottage residency with a painting, 'The Fall of Lucifer', about the separation of the dark from the light. Two works followed which concerned themselves with metaphysical notions of light; these are 'The Cells of Night' (cat.no.5) and 'The Promise' (cat.no.10). Both are concerned with night, with preparations for the dawn, for a new birth; they show us things pregnant with life. They take us

back to the theme of 'Maternity' of 1929 but they also lead us forward to what happens at dawn, at the birth.

The lunar craters in 'The Cells of Night' are the most three-dimensional passages in Collins's paintings. He remembers that he prepared his support, either canvas or plywood, with a glue layer and then a thick application of lead white oil paint, laid on to reveal a prominent texture. While this lead white layer was drying, (it could take up to six weeks before it was perfectly dry) he used to scratch into it with a needle to further enliven the texture. When this white textured ground was dry, then oil paint of a thinner consistency was applied to create the images. In order to follow such a procedure, it is obvious that the artist had to plan what he would do. Possibly a simple pencil or charcoal line mapped out the main shapes of the composition at the lead white stage. However, Collins prepares a painting clearly in his mind's eye before he begins (indeed some works have been so complete and satisfactory in that state that they have stayed there and not found physical expression) and preparatory drawing is hardly necessary. Also for Collins drawing is an end in itself and not a preparation for painting. One function of the thick lead white ground is that it provides the painting with its own layer of inner light as it were, and by scratching back into this, the various layers of the paint become interrelated and the surface is moulded by a rich variety of means. Certainly the scratched textured ground of the female head in 'The Cells of Night' provides it with its own special luminosity. A richly textured ground is first seen underlying the angelic figures in 'The Fall of Lucifer', and again over the whole surface but particularly under the configurations of the largest planet or celestial body in the sky of the painting 'A Song' (cat.no.6). The main images in 'A Song' are an island-like form with leaves and flowers and shells on the shoreline, with celestial bodies in the sky above. An angelic weightless figure holding a single flower floats to the left of the island. The flowers have white chrysalis/angel forms at their centres and send out rays of light. The shell forms resting on the seashore are the first appearance of this subject in Collins's work. They recall childhood memories when Collins put shells to his ear and listened to the sound of the sea in them. When asked about the nature of the song in this composition, the artist replied that the song was a lure; it enticed like the mermaid's song, which was only heard by sailors and conveyed back to others by rumour. Both the shells and the notion of the mermaid's song point to the emergence in this painting of the idea of the sea. The sea has always been a fundamental theme in the artist's life. He was born and spent his childhood near the sea and has significant early memories about seeing and hearing it. Equally the sea in a wider sense is symbolic of a great

unfathomable power, the primordial waters are the source of life and the waves beat out the message of endless motion and a continual journeying.

The sea emerges as a crucial symbol in the paintings which follow 'A Song'. Its watery presence is conveyed by the sinuous curves of the forms in 'The Eternal Journey' (cat.no.7), and it is the major component of both 'Virgin Images in the Magical Processes of Time' and 'The Quest' (cat.no.14). It is still potent in works of the late 1980s, for example 'Walking on the Waters', 1986 (cat.no.59). Collins's symbolism and imagery is very complex in the mid 1930s, when he is working through his ideas as to what a painting should be and should do. The objects in these paintings 'are not related optically, but instead are related according to the dictates of the soul'. Collins believes painting to be 'a metaphysical activity' and 'paintings are stations of transmission'. What he was doing in the 1930s, and is still doing, is to convey through archetypal or mythic imagery universal and enduring mystical ideas. He is not trying to be original or to express his own particular autobiography. Therefore his paintings do not convey any representations of his exterior world. But they do reveal his interior world, even if the artist would state that self-expression is quite alien to him. The period spent studying mystical texts triggered a latent longing in Collins to be involved in the chain of communications about man's desire to return to the Godhead, the source of all light and love. Although by the early 1930s he had shown tentative beginnings in the poetic field, Collins chose the materials of paint, ink, pencil and watercolour for the unenviable task of conveying a visual idea of the origin of all things earthly and heavenly.

Questions about the origin of the universe and all its abundant forms were popular in the scientific worlds of the 1930s. Three men in particular – Sir Arthur Eddington (1882-1944), a Cambridge professor of Astronomy, Charles T. R. Wilson (1869-1959), a Cambridge professor of Natural Philosophy, and Arthur H. Compton (1892-1962), Professor of Physics at Chicago University, were prominent in research and in the promotion of their findings to a wider audience. Collins was a member of this audience and eagerly read of macrocosmic and microcosmic forms, cells, stars, nuclei and atmospheric electricity for example. A book still in his possession is 'The World beneath the Microscope' by H. Watson-Baker. He was able to introduce a range of cellular and crystalline forms into his paintings of the 1930s that were newly offered to him through publications on such topics. Compton was director of the World Survey of Cosmic Rays from 1931–33, and the first visual counterparts of cosmic

rays enter Collins's work in 1934, in the beams of light radiating from the flower heads in 'A Song'.

In the mid 1930s Collins also began to make use of forms currently enjoying a great vogue in avant-garde artistic vocabularies. English artists interested in the recent development of Surrealism in France developed their own responses to it. Artists like John Banting became fascinated by all forms of life, animal, vegetable and mineral and went to exhibits in the Natural History Museum for inspiration. The life cycles of butterflies and moths caught the attention of Roland Penrose and Ithell Colquhoun but the form that became almost a symbolic emblem, particularly in the sculpture and drawings of Henry Moore, was the bone. Bones stripped clean of flesh offered an archetypal, symbolic essence of man, and reminded the viewer of the eternal cycle of growth and decay. Collins introduced bone forms into his paintings and drawings *circa* 1934, a handful appear in a section of 'The Eternal Journey', and bones lie on the ground over which the Pilgrim traverses (cat.nos.70 and 71), but when they appear they show signs of life. He wanted to transform the ideas of decay and death, what he termed the 'death landscape of the Surrealists', into one of regeneration, resurrection even. Rays of light shine out from the bone forms employed by Collins. One of the visions of the prophet Ezekiel (Chapter 37, v 1–14) concerned a valley full of dry bones which the Lord made to live again by breathing on them. T. S. Eliot, in his poem *The Waste Land*, made use of the imagery of bones and drought; salvation would arrive in the form of life-giving water. In Collins's painting 'The Poet: Image with Forms' (cat.no.8), bone forms set among a dark landscape are interspersed with chrysalis and butterfly forms.

When 'The Eternal Journey' was first shown in 1935 it was exhibited under the title 'Archegenesis'. The word is tautologous, it says the same thing twice within itself and therefore doubly stresses its meaning. The prefix of 'arche' comes from the Greek 'to begin' and 'genesis' naturally means 'the beginning, the origin, the primary mode of generation'. With its two titles, this painting thus refers to a journey which had a beginning but now stretches through the future to infinity. Collins's readings of mystical texts had confirmed an eternal truth to him, that man is seen as a pilgrim on a restless journey through life. 'Thou hast made us for Thyself and our heart is restless until it rests in Thee', St Augustine (Confessions). The goal of the pilgrim is to return to his original homeland, something we symbolically call the Garden of Eden or Paradise. In *Little Gidding*, Eliot found magnificently simple words to express this:

We shall not cease from exploration
And the end of all our exploring
Will be to arrive where we started
And know the place for the first time.
Through the unknown, remembered gate
When the last of earth left to discover
Is that which was the beginning;

Having come to a realisation and an understanding of what he considered to be fundamental truths in the execution of his paintings and drawings of the 1930s, Collins must have felt how bound he was, in order to be true to himself, to spend the rest of his life presenting these metaphysical truths to others. It was a difficult programme that he set for himself, and to his credit, it is one that he still follows today. The paintings of the mid 1930s, from 'The Cells of Night' of 1934 to 'The Voice' (cat.no.13) and 'The Quest' completed in the autumn of 1938, offer the imagery of cosmic worlds, primitive life forms, and the power of the sea, subjects that do not admit the presentation of everyday facts and figures, such as the basic human portrait. However, in the year that marked the beginning of the Second World War Collins returned to the genre of portraiture and produced a serene and richly detailed icon of domestic happiness, 'The Artist and his Wife'. There are details in this painting that are copied from his immediate surroundings, painted as it was in a new bungalow, Swan Cottage, in a quiet road on the outskirts of Totnes. The window handle is true to life and the back garden of Swan Cottage had a central path and two areas of lawn bounded by a row of trees, beyond which was open land with a small wooden pavilion, much as it is presented here. A wooded hill with its soft peak was visible from the back garden, but was further over to the right; artistic licence has brought it back to fill the background and to make its summit appear as the focus of the garden path. The leaves scattered on the table link the interior with the exterior world. The two figures of Cecil and Elisabeth Collins sit beside a table and seem to be about to partake of a sacramental meal, with fruit and two chalices on the table, and with both of them holding an ankh in their right hands, their painting hands. Collins sees the domestic table laid with various simple objects or with a white cloth as symbolic of an altar. Thus this double portrait presents these two artists as priests in a ritual. Collins was to write later that 'The artist should have the same functional rights as the priest'.

In the paintings of the Dartington period 1939–1943 which follow this work, more figures appear and take part in ritualistic actions. In 1943 the figure of the Fool arrives in painted form; he had already found graphic

form as early as 1939 (see cat.no.85). The Fool is Collins's most significant creation; he started life as a private symbol and then as the realization of what he would signify grew within the artist's mind, he was offered as a hopeful statement in the midst of pessimistic and troubled times. When many of Collins's peers, for example Sutherland, Piper and Moore, were recording the devastation of mind, body, landscape and cityscape in the years of the Second World War, Collins refused to document any signs of destruction, just as he omitted to paint hell at the bottom of 'The Fall of Lucifer'. He was summoned to a medical examination in Exeter in 1942 to ascertain whether he could be called up for service, but the examination revealed that his physical state was not compatible with that necessary for a fighting man.

The Fool dominates Collins's painted output during 1943, journeying, sleeping, dreaming, fully absorbed with an innocence of spirit in these activities. Collins wrote of him in 1945 'The idea of the Fool had ... been strongly with me many years before I commenced my paintings; but not as a concept, it was a particular quality of emotion, generated by the experience of being alive, and by contemplating the spectacle of contemporary society'. Although Collins writes that the idea of the Fool had lain dormant within him for many years, he now acknowledges that the midwife at its birth into his art was his wife Elisabeth. Cecil and Elisabeth were friendly with the members of the Jooss ballet, an avant-garde German troupe resident at Dartington, and indeed trapped there while their touring schedules were made nonsense of by the war in Europe. Cecil and Elisabeth joined in the ballet workshops on occasion, helping with set and costume designs, and watching the choreography develop. After one of these occasions, Elisabeth produced a drawing in pencil and ink wash, dated March 1939, which shows three figures behind a low wall coolly looking at a wounded fool who lies on the ground with a spear piercing his heart. This was a cathartic moment for Collins, who was then able to begin his own series of Fools. He began to write about the Fool between 1942 and 1944, defining his spirit as one of 'purity', 'ironic innocence', 'wit', 'energy', 'compassion' and contrasting it with 'The manifest bankruptcy and sterility of contemporary society'. 'The Fool rejects modern society, because the Fool represents that profound fertile innocence, down from which we have fallen, into the dirt and filth of mechanical existence'. For Collins the Fool was there at the beginning of life and thus can offer a whiff of Paradise to fallen mankind.

Collins's first essay on the Fool – *The Anatomy of the Fool* – was printed in a periodical called *Transformation*, the third number of which appeared in 1945. *Transformation* was co-edited by Stefan Shimanski

and Henry Treece, and the latter was a founder member of a group of poets who styled themselves 'The Apocalypse'. Other members were J. F. Hendry, Nicholas Moore, G. S. Fraser, Vernon Watkins and Alex Comfort (who was responsible for the first book on Collins's work, in 1946). They distinguished their work from other contemporary poetry, for example that written under the influence of Surrealism, by pointing out that they were not interested in outpourings of irrational thought. This sentiment was exactly mirrored by Collins in his writings and in his art. The impulse behind the founding of the Apocalypse group was the urge to counter via poetic means the growing mechanisation, barbarism and sterility of contemporary society, and in Collins these poets found a sympathetic voice. A larger essay by Collins called *The Vision of the Fool* was published as a book with illustrations of his work by the Grey Walls Press in 1947. This press was founded and run by Wrey Gardiner, a friend of the Apocalyptic poets Moore and Comfort. Gardiner was born in Plymouth, like Collins, and they shared not only a view of the poor state of contemporary society, but also the same Celtic background. Collins appears to have tried out his ideas about the Fool and his vision on Gardiner, for Gardiner writes how he was 'strongly drawn towards the philosophy of the fools which Collins is working on. It appears in my own poetry'. Before either of these texts reached publication Collins was given an exhibition at the Lefevre Gallery, King Street, London in February 1944, and there he showed the fruit of his Dartington years, with the major part of the show given up to paintings and drawings of Fools. King Street was badly bombed on the night of 23rd February and Collins's exhibition was blown off the walls; Gardiner wrote in an autobiographical essay published in 1947 how this seemed to him symbolic of the fact that Collins's important and hopeful message to society via the Fool was in grave danger of not getting through. Gardiner was wrong, for although all the Fools fell 'into the dirt and filth of mechanical existence' heaped on the floor of the Lefevre Gallery, they were examined by the staff, dusted down and resurrected. Ten of them are in the present exhibition to testify to their powers of endurance.

Images of the Fool began to grow less frequent in Collins's paintings and drawings by the late 1940s and the symbol hardly makes an appearance in his art again until the late 1960s. As the Fool temporarily leaves the stage, he is replaced by the Angel and the Anima. Angelic figures crowded as witnesses on to the rocky plateaux in the scene of 'The Fall of Lucifer' and then single robed and winged figures float in immeasurable space in 'A Song', 'The Eternal Journey', 'Virgin Images in the Magical Processes of Time' and 'Images in Praise of The Love' (cat.no.11). Then there is an

absence of angelic presences between 1936 and the late 1940s. A group of angels personifying energy dance with the sun and the moon in a large painting of 1949 (cat.no.29), and bring the subject back into Collins's work.

Angels throughout most civilizations have been seen as a class of spiritual beings who, acting as messengers of the gods, are the agents of divine will and its execution on earth. In the Christian art of the West angels are usually winged, of indeterminate sex and dressed in loose flowing draperies. They form themselves into hierarchies and one group sings and plays music, and this heavenly choir is responsible in part for the music of the spheres. Collins's angels bear a physical resemblance to those of Western Christianity, but as they continue in his work through the 1960s, 70s and 80s they grow more grand and awesome, and seem to take on more of the divine spirit for themselves, rather than just acting as its channel, see for example 'Landscape of the Threshold' (cat.no.41), 'The Guardian of Paradise' (cat.no.42), 'The Angel of the Flowing Light' (cat.no.49), 'Head of an Angel' (cat.no.60) and 'The Music of Dawn' (cat.no.65). Because Collins has always been intent on presenting his subjects with great clarity, he is aware that to offer a painted image of an angel could cause embarrassment to a viewer who doubts that they have a presence on any level, particularly if the viewer is affected by the 'bankruptcy and sterility of contemporary society'.

'You can't get a foothold there if you are a rationalist. With the Fool you might get it, or with the Anima, but the Angel, no. And that is the importance of the Angel. It allows of no compromise. The mind has to make a leap immediately, and the Bible is quite right, the Angels are something we have to wrestle with . . .'

The angels in Collins's paintings rarely set foot on the earth; the strife of life here is damaging and wounding to the weaker ones, see 'Wounded Angel' (cat.no.48), who has to take rest and refreshment in Paradise. Angels lie wounded at the bottom of the scene of 'The Fall of Lucifer', but their wounds are holy ones, inflicted by other angels. The one angel that walks on the earth's surface is the one that guides the Fool, see 'Fool and Angel Entering a City' (cat.no.50), and it can join the Fool in his pilgrimage because the Fool, with his innocence and purity of spirit, is willing to listen to its voice. Equally, it takes a Fool to recognise an Angel.

Although the angels are messengers of light and love, they are more distant as a symbol than the Anima, or sacred feminine spirit. The Anima grows from girlhood into womanhood as Collins's paintings proceed chronologically. Collins's constant Anima is his wife Elisabeth, his muse, and she has provided him with the model of the feminine as compassionate

counsellor. A golden-haired female child accompanies the Pilgrim Fool away from a burning city (cat.no.19) and shows no fear. Another female with golden hair sits in reverie under a tree and keeps the company of a sleeping Fool (cat.no.24). Although the Anima appears as a Bride (see cat.nos.25 and 43), she is never presented as maternal. (The painting of 'Maternity' precedes the development of the Anima.) Collins has only produced two small ink drawings on the Mother and Child theme (for one see cat.no.83), and it is obviously not a subject that he wishes to develop. The naked young woman in 'Hymn to Night' (cat.no.31) awaits some initiation, some rite of passage and a tender angel hovers near as guardian or witness. Mirroring the way that Collins's angels grow in strength and wisdom, his Anima figures undergo a similar transformation. They appear from the 1950s on as Sibyls and Priestesses (see cat.no.39), performing duties as messengers or mouthpieces of the gods.

Collins initiated a change in his painting technique in the mid to late 1950s. He eschewed a thickly brushed lead ground and carefully painted detail applied in layers, in favour of oil paint thinned down with turpentine. This was an intuitive response to the need for change in his manner of working. He can see, with hindsight, that as he continued producing clear and unambiguous images, he was slightly in danger of going down a path of 'contracting formality'. A period of heightened energy levels helped him to develop his 'matrical' procedure. This consisted of beginning with a loaded brush with a different colour in each hand, the eyes shut, and a gestural attack with the pigment on to the support. With the opening of the eyes, an image or idea emerged from the working of the paint. A fluid and creative collaboration between materials and manipulator ensued. Most of these 'matrical' paintings grew into female images, Sibyls, Priestesses, Brides (see cat.nos.39 and 43), although some became landscapes of mood (see cat.nos.38 and 46). The 'matrical' procedure was for Collins equivalent to the execution of a rite and it also performed for him a rite of passage. It delivered him into a phase still being worked through today. The paintings of the 1970s and 80s can be characterised by words such as gravity, directness, simplicity and solace. They are a distillation and a summation of the preceding decades. Collins still has more painting to do; he talks of some still lifes and a return to a series of 'rooms of childhood'. Once he is relieved from the entanglements which accompany a large retrospective exhibition, he will be free, like his Fool and his Pilgrim, to carry on with his journey.

Collins's first prolonged and concentrated period of drawing was as a student at Plymouth School of Art where he was encouraged to take six weeks over the drawing of a cast of a piece of classical sculpture. At the Royal College of Art he enjoyed drawing from life, and his first extant drawings date from this period (see cat.no.66). In their subject matter they give no hint of the complex graphic images that were to follow, but in their technique they adumbrate the soft pencil drawings of the mid 1950s and the mid 1970s. Since leaving the Royal College, Collins has not drawn from life, only from the imagination. As a student at the Royal College Collins admired the graphic work of Ingres and one of the earliest drawings in this exhibition is a portrait drawing in pencil of his wife Elisabeth (cat.no.67). Her face is shown in three-quarter view and the elegant line of her left brow, cheek and chin is emphasised by the use of diagonal hatched soft shading. Collins learnt to convert this kind of shading into a gentle haze around drawn pen lines, see for example 'Bird Singing in a Tree' (cat.no.110), where the pencil provides a different tonality, almost a different colouristic value, to the black ink.

A large ink drawing with watercolour washes, 'The Sitting Room at Monk's Cottage' (cat.no.68), executed in 1932, indicates a new phase in Collins's graphic career. He deliberately set up limitations for himself in the execution of this large watercolour by only using a matchstick end to make the ink lines. The colour is washed on in patches, none of which merge with another, thus leaving the colour pure and fresh, providing an environment of peace and harmony. The subject matter of this drawing mixes the realistic recording of a domestic interior with the depiction of an extra-sensory visitor. In his paintings contemporary with this drawing, Collins produced compositions of scenes with angels at peace in green and verdant pastures, but never in these works did he link the angels, visitors from another world, to his own quotidian domestic life. This presentation of a visitor from a supernatural world works well in this technique and serves to indicate how closely Collins's material means and his subject matter are enmeshed.

The period of Collins's working life which he spent in the peace of Highwood Bottom contains a large body of drawings. The high viewpoint and distorted perspectival composition of 'The Sitting Room at Monks Cottage' appears to loosen the stability of the room, and the curving strokes of colour in the bottom left-hand corner begin a sense of eccentric movement which is taken up in some pen and ink drawings of the

following year. Three ink drawings are known to date from 1933, and all of them shun clearly defined imagery in favour of amoeboid forms, some of which are penetrated by radiating rays. The three works are 'Composition' (repr. Anderson, pl.13), 'Angel Images and Negative Spectres in Conflict' (repr. H. Read, Surrealism, pl.21) and 'The Music of the Worlds' (cat.no.69). These drawings look like necessary experiments in order to find a way of depicting cosmic forces, for this was the field of subject matter that Collins was exploring during 1933. It is difficult to capture with ink and wash such awesome ineffable matters as planets whirling and humming on eccentric courses through space, and metaphysical battles between the forces of good and evil, but Collins was prepared to attempt to get an equivalent down on paper.

In 1935 Collins initiated a technical experiment; instead of drawing with dark lines and washes on a white or light ground as previously, he began to draw with white ink upon a coloured ground. 'White writing' or a network of touches of white pigment over a darker toned structure which provided the essential form has been an aspect of the drawing tradition of Western Europe since early Renaissance times. Collins did not use it in this way, because he did not combine it with an earlier layer of dark lines in order to enhance a sense of volume and chiaroscuro, although a single example, 'The Pilgrim' (cat.no.71) can be claimed for this category. The white lines of his compositions serve to make his subject material appear more ethereal. Collins has always been interested in the complementary and transforming (even alchemical) aspects of silver and gold, which can be symbolised as the light of the moon and the light of the sun. From 1933–36, much of Collins's work is concerned with moonlight, nocturnes, a silvery mood, eg. 'The Cells of Night', 'A Song', and 'The Promise'. The white light of this group of drawings (cat.nos.71, 72, 73, 74 and 75) complements the theme of the paintings, and the white lines constitute a reversal of normal tonal expectations.

When Collins was at Dartington, he ushered in a new and most inventive drawing style, see for example 'Procession of Fools' (cat.no.86). The earlier colour washes and gouache-filled forms were eschewed in favour of a pen line, often the instrument was a quill pen with its directional thin/thick strokes, which has an electric vitality. Drawing ink is a medium that allows for variety, because it can be used at full strength or thinned with differing amounts of water to produce modulations of tone. Collins favours Chinese carbon ink in stick form which can be ground down to produce a scale of tones from dense to pale. Differentiations of light and shade can be produced not only by the quantity and quality of ink used but also by the variety and rhythm of calligraphic

marks made. Collins's calligraphic marks have the look of being produced spontaneously, intuitively and with speed. Collins's 'matrical' paintings, with thin oil paint laid with a brush at speed and with rhythm on to the support, preserve this quality of movement so apparent in the ink drawings.

It is salutary to remember that drawings are done with a point that is moved by a hand. As the hand moves on, it leaves behind a fixed mark. Collins has been involved, in his own drawings and in his teachings, in enlarging the ways that the mark is made. He has devised several ways of holding the drawing point, these include the mouth and toes, and the use of differing arm movements and varying pressures. (His drawing classes at art institutions have a most liberating effect upon the students, and the author of this catalogue was enchanted to discover a latent graphic talent in her right foot.) Not only the reed, metal nib or quill pen, but also the pencil, in Collins's inventive hand, can function as a drawing instrument of great variety. He wrote in 1976 of 'the pencil with its wide range of touch and dynamic' and one of the main ways he has varied his touch has been to produce an additive line, made up of separate short touches; two major examples of this are 'The Resurrection' (cat.no.122) and 'The Agony in the Garden' (cat.no.125). The lines which describe the contours or limits of the forms in these drawings are composed of an accumulation of short, separate pencil strokes and the effect is one of tenderness and yet strength. The accumulated strokes are darkest in tone towards the centre of the bundle and weakest at the outer edges. This produces a halo effect which is most empathetic for the subject matter of these two works. Collins has created a most successful yet ultimately mysterious analogy between the subject and its two-dimensional reality in the form of pencil marks on paper.

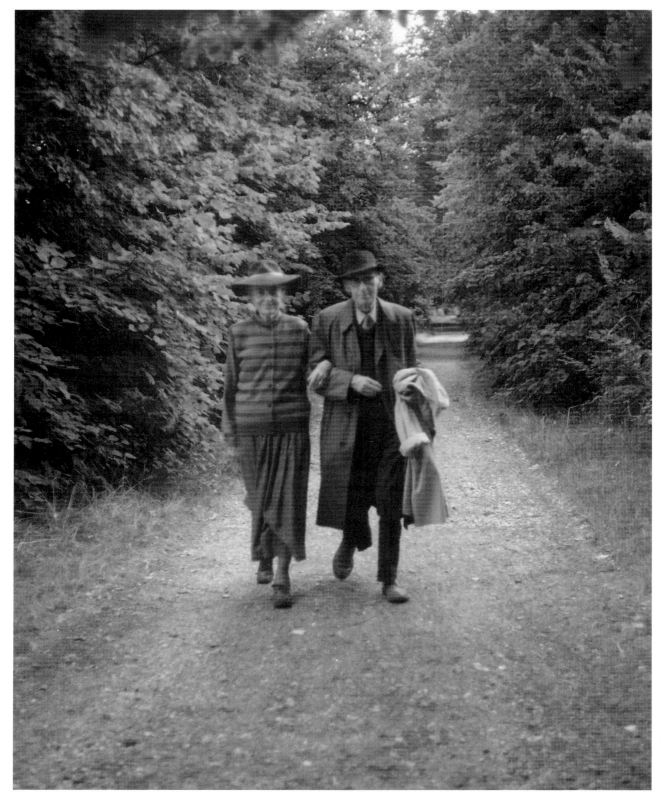

Elisabeth and Cecil Collins, 1988

Chronology

1908

23 March: James Henry Cecil Collins born at 2 Bayswater Terrace, Plymouth.

1922–3

Apprenticed to a motor engineering firm at Millbay in Plymouth Docks.

1924–7

Attended Plymouth School of Art.

1927

Death of Collins's father. Won scholarship to the Royal College of Art, London, and studied there until 1931, winning the William Rothenstein Life Drawing Prize. Lived in a room in Gunter Grove, London.

1931

3 April: Married Elisabeth Ramsden, a fellow student at the RCA. They took a flat at 52 Redcliffe Road, London. Also rented a house in the country, Monk's Cottage, Highwood Bottom, near Speen,

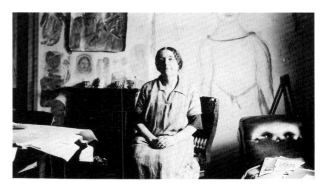

Collins's mother in front of her drawings done directly on to the wall, c.1930s

Collins as a student at Plymouth School of Art, c.1924–7

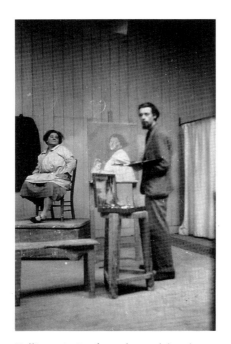

Collins painting from the model at the Royal College of Art, c.1927–31

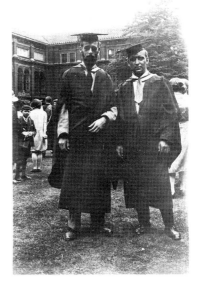

Collins, on left, on Royal College of Art diploma day, in the courtyard of the V&A Museum, 1931

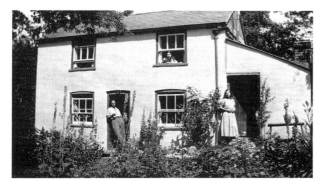

Monk's Cottage, Highwood Bottom, with friends at doors and window, *c*.early 1930s

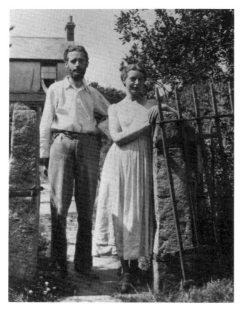

Cecil and Elisabeth outside Springhill, Highwood Bottom, *c*.mid 1930s

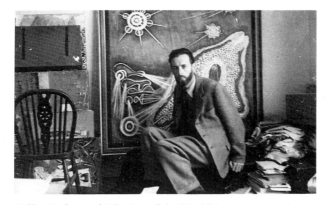

Collins in front of 'The Joy of the Worlds' cat.no.12, at Swan Cottage, Totnes, *c*.1937

Buckinghamshire. At Monk's Cottage met Eric Gill and David Jones; Gill's diary for 1931 records supper at Monk's Cottage with his wife Mary on 20 November.

1933

Short visit to Paris and saw work by Paul Klee.

1934

6–24 February: *Exhibition of Paintings and Drawings by Mark Tobey*, Beaux Arts Gallery, Bruton Place, London. Collins met Tobey at the time of this exhibition and they became friends.

1935

16–29 October: First one man exhibition at the Bloomsbury Gallery, London (56 works). Introduced to Stanislas Ossiakowski and his wife Jean Druce, owners of the Bloomsbury Gallery, by his friend Julian Trevelyan. After this exhibition Collins and his wife moved to another house in Highwood Bottom, called Springhill. They stayed there until the autumn of 1936. Mark Tobey stayed with the Collins's at Springhill.

1936

20 February: First poem published in the *New English Weekly*. 11 June–4 July: Two works included in the *International Surrealist Exhibition* at the New Burlington Galleries, London. Autumn, moved to lodgings in Totnes, Devon, to be close to Tobey at Dartington Hall.

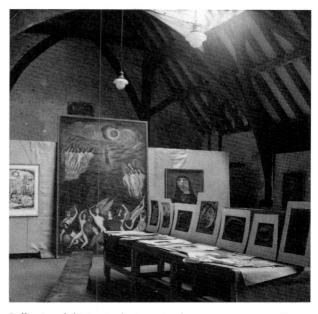

Collins's exhibition in the Barn Studio at Dartington Hall, June 1937

1937

Moved to Swan Cottage, Weirfields, Totnes. 17–29 June: Exhibition of Paintings and Drawings in the Barn Studio, Dartington Hall (65 works).

1939

5–25 August: Taught painting at Dartington Hall Summer School; other tutors were Hein Heckroth, Bernard Leach and Willi Soukop. At the outbreak of war, the Collins's moved from Swan Cottage up to Dartington Hall, staying in the house of Margaret Isherwood in Park Lane.

1940

10 March–21 April: *Panorama* exhibition at the Barn Studio, Dartington Hall, which consisted of Roland Penrose's collection of works of art, with the inclusion of one work by Collins, and one work by Heckroth. Summer: Heckroth interned as an enemy alien, and Collins takes on role as tutor in painting and drawing, Arts Department, Dartington Hall, with a basic class of seven students, mostly foreigners. The Collinses moved from the Park Lane house to a room in the East Wing, Dartington Hall. Cecil was provided with a small studio behind the Barn Studio.

1941

25 May: Introduced Herbert Read's lecture 'The ABC of Art' at Dartington.

1942

Collins begins to write his essay, The Vision of the Fool.

1943

Death of Cecil Collins's mother. 15–19 June, John Piper stayed at Dartington Hall, and made contact with Collins. Trips to London, lodging at Carlton Mews, St James's, London. Gave up rooms and studio at Dartington by 31 December. The Contemporary Art Society, in the person of John Rothenstein, buys 'The Sleeping Fool' from the artist.

1944

February: Exhibition of Paintings and Drawings, Lefevre Gallery, 1a King Street, St James's, London (50 works). By 5 February living at 30 Royal Avenue, Kings Road, London. King Street hit by bomb on the night of 23 February, and Collins's exhibition at the Lefevre Gallery blown off the walls. The Collins's were staying in Yorkshire at the time. By 29 July, Cecil and Elisabeth Collins were living at 12 Newnham Terrace, Cambridge, in a bed-sitting room, with an attic room as a studio, lodging in the same house as their new friend Robert Nichols, the poet. In September, the

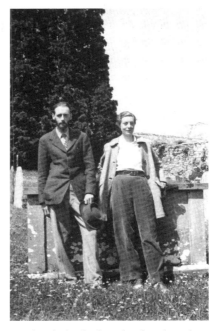

Cecil and Elisabeth in the churchyard, Dartington, *c*.1940

Cecil and Elisabeth with Jooss Ballet members, Dartington, *c*.1940

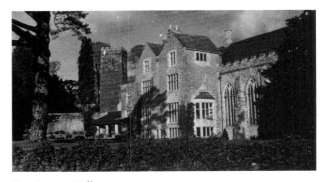

Dartington Hall, *c*.1943

Views of Elisabeth's family home, Hollins, Luddenden, Yorkshire, in the 1940s

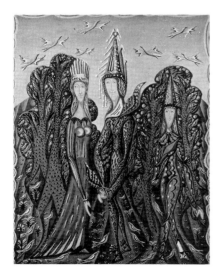

Collins's design for the tapestry 'The Garden of Fools', c.1949

Collinses were at Hollins, Luddenden, near Halifax, Yorkshire, the home of Elisabeth's parents, for a holiday. On 8 December, Cecil Collins wrote from Cambridge to Dorothy Elmhirst at Dartington to tell her of a proposed book on his work. On 24 December, Paul Nash wrote to Collins, asking him to write the text for an illustrated book on Nash's work.

1945

In April the Collinses stayed at Hollins, Yorkshire. On 3 May, Cecil wrote to Dartington from 12 Newnham Terrace, Cambridge, 'on the track of a flat in Oxford'. By 21 October moved into a flat at 2 Ralston Street, Tedworth Square, Chelsea. December, exhibition of New Watercolours and Drawings and some prints (shared with Katharine Church) at Lefevre Gallery, 131–4 New Bond Street, London (67 works).

1946

Spent time in Oxford, meeting Conrad Senat and the poet Alex Comfort. Comfort's book on Collins *Paintings and Drawings 1935–45*, the first book on the artist, published by Counterpoint Publications, Oxford.

1947

The Vision of the Fool published by The Grey Walls Press, London.

1948

March: New Paintings by Cecil Collins (shared with New Paintings by Robert Medley), Lefevre Gallery, Bond Street, London (32 works). The Collinses were living at 7 Grange Road, Cambridge by 3 February, and for a while Cecil used as a studio there the stable of Enid Welsford, author of *The Fool: His Social and Literary History*, published 1935. Commissioned by the Edinburgh Tapestry Company to produce a tapestry design.

1949

Collins's tapestry entitled 'The Garden of Fools' (68″ × 51″) woven by the Edinburgh Tapestry Company. 3 December, 'Self-Portrait' drawing reproduced on the cover of *Art News and Review*, with accompanying article by Bryan Robertson, a new friend in the Cambridge art world.

1950

January–February: Exhibition of New Paintings (shared with Francis Rose and Merlyn Evans) at the Heffer Gallery, Cambridge (18 works), the first exhibition of Collins's work organised by Bryan Robertson.

1950–4

Numerous short trips to France, Italy, Germany and Greece.

1951

By 18 April the Collinses were living at 8 Grange Road, Cambridge. Friendship with Frances Cornford. By 8 September, they were living at 15 (later renumbered 35) Selwyn Gardens, Cambridge. 30 October–20 November: Exhibition (46 works) at the Leicester Galleries (shared with Mary Potter). Offered part-time teaching at the Central School of Art by William Johnstone, which entailed commuting between Cambridge and London; shared the teaching of the life classes with Mervyn Peake. First painting enters The Tate Gallery collections, 'The Sleeping Fool', presented by the Contemporary Art Society.

1952

April: Trip to the south of France in the company of Michael Rothenstein.

1953

April: Exhibited with the Society of Mural Painters at the RIBA. October: Exhibition at the Ashmolean Museum, Oxford (23 works).

1954

Tapestry 'The Fools of Summer' (65″ × 84″) woven by the Edinburgh Tapestry Company.

1956

February–March: Exhibition at the Leicester Galleries (37 works) shared with Eliot Hodgkin and Terry Frost. The Edinburgh Weavers produce two linen fabrics designed by Collins, 'The Herdsmen' and 'The Fools'. Collins's connection with the Edinburgh Weavers was due to his friendship with Hans Tisdall, whose wife worked for them.

1958

Won prize of £100 in the first *John Moores Liverpool Exhibition* for his painting 'Christ before the Judge'. Visit to Aix en Provence, France.

1959

Commissioned by the Ministry of Works to design a fabric for the curtains of the New Conference Hall at the British Embassy in Washington, USA. The fabric, a cotton and rayon mix produced by the Edinburgh Weavers, was entitled 'Avon' and depicted eight Shakespearian characters. October, living at 1 Eaton Terrace, Sloane Square, London. November–December, Retrospective exhibition of work from

Collins in stable studio, Grange Road, Cambridge, with 'The Bride,' cat.no.25, on the easel, *c.*1950

Elisabeth and Cecil with friend at Menton, France, April 1952

Cecil, Elisabeth, Bryan Robertson, unknown, Elizabeth Vellacott, unknown, on the steps of the Heffer Gallery, Cambridge, *c.*1950s

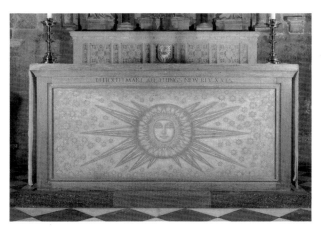

Collins's altarpiece 'The Icon of Divine Light', Chichester Cathedral, 1973

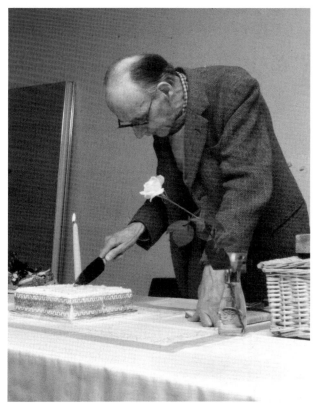

Collins cutting 80th birthday cake, Central School of Art, 1988

1928–1959 at the Whitechapel Art Gallery, organised by Bryan Robertson (227 works). Collins took lessons in lithography from Ernest Dalglish.

1960

Became an official, along with Nan Youngman, of the Cambridge Society of Painters and Sculptors, which was founded in 1955 for the purpose of holding annual exhibitions of members' works.

1961

One man exhibition at the Gallery Zygos, Athens (54 works), arranged through the poet George Seferis, Greek Ambassador in London. The Greek National Gallery bought work from the show.

1963

Invited to speak at the annual conference of the Centre for Spiritual and Psychological Studies; Collins's talk was entitled 'Art and Modern Man'.

1965

23 February–13 March: Exhibition of Recent Paintings at Arthur Tooth & Sons, London (31 works).

1967

1–25 March: Exhibition of gouaches and watercolours, Crane Kalman Gallery, London (26 works).

1968

Commissioned by Oxford University Press to make pencil drawings to illustrate the *Psalms*, the book of *Ezekiel* and the *Song of Solomon* for the *Oxford Illustrated Old Testament*.

1970

Moved to London, where the Collinses still live. Began to teach drawing for adult classes at the City Literary Institute; this teaching post lasted until 1987.

1971

28 September–16 October: Exhibition of Recent Paintings at Arthur Tooth & Sons, London (30 works).

1972

1–25 November: Retrospective exhibition of work from 1936–68 at the Hamet Gallery, London (62 works). Met the composer Karlheinz Stockhausen.

1973

3 November: Consecration of Collins's altarpiece, The Icon of Divine Light, painted for the Chapel of St Clement, Chichester Cathedral. Elisabeth Collins designed the kneelers for this chapel.

1975

Asked to retire from his teaching post at the Central School; letters from artists in his support. Lectured at Tate Gallery on 10 June and at Dartington Hall.

1976

24 June–23 July: Exhibition of New Drawings, Anthony d'Offay Gallery, London (26 works).

1978

Arts Council commissioned a film on Collins, 'The Eye of the Heart', made by Stephen Cross.

1979

Awarded the MBE.

1981

5 August–1 November: Print Retrospective, Tate Gallery (55 works). 21 October–14 November, Exhibition of New Works, Anthony d'Offay Gallery, London (73 works). Conversations with Artists, BBC Radio Programme, with Edward Lucie-Smith. Reissue of the book *The Vision of the Fool*. Publication of a book of poems written between 1940–81, '*In the Solitude of This Land*'.

1983

November–December: Retrospective exhibition, Plymouth Arts Centre (40 works).

1984

9–24 June: Exhibition at the Festival Gallery, Aldeburgh (44 works).

1985

1 November: Consecration of side windows, church of St Michael and All Saints, Basingstoke, commissioned by Canon Keith Walker. Collins gave an address from the pulpit on angels.

1988

Eightieth birthday celebrations at the Central School of Art, the Chelsea Arts Club and the Royal College of Art. Elected RA.
26 May: Consecration of West window, church of St Michael and All Saints, Basingstoke.
1–23 June: Recent Paintings, Anthony d'Offay Gallery, London (32 works).

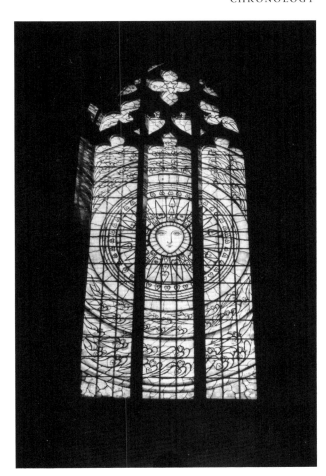

West window, 'The Mystery of the Holy Spirit', St Michael and All Saints, Basingstoke, 1988

C'est dans ce centre que l'homme rêve le rêve
Profondément caché de sa vie, ce rêve où s'unissent la haute
Conscience de l'Esprit et l'obscure existence du corps.

Troxler

It is in this centre that man dreams the dream deeply hidden from his life,
the dream where the spirit's sublime consciousness and the obscure
existence of the body unite.

Troxler

L'Art est une Reminiscence à moitié effacé d'une condition meilleuse dont nous sommes déchus depuis l'Eden.

Saint Hildegarde

Art is a half effaced recollection of a higher state from which we have fallen since the time of Eden.
Saint Hildegarde

Writings and statements by the artist

Painting considered as a theatre of the soul, in which the mystery of the life of the soul is reenacted. I have always been concerned with Art as poetic consciousness, as metaphysical experience, and in my painting I have sought to explore the mystery of consciousness. A picture lives on many different levels at once, it is an interpenetration of planes of reality, it cannot be analysed or anatomised into single levels because one level can only be understood in the light of others. The reality or interior life of the picture can only be realised as a total experience. Partial experience, aestheticism for example, seems superficial.

It is my strong conviction that one of the functions of Art is to help free man from the bondage of transient emotions and from the slavery and prison of the world of small desires, the hypnosis of time.

The subject or theme in a picture has a profound, subtle and unique relationship with the Artist and with other human beings who experience the picture. This is something we still do not understand, and do not give enough attention to. There is much misunderstanding over this question of the subject, it is not sufficiently realized how a subject functions in a picture. A subject is thematic energy, the theme in Art is a focus, a canalisation of visual energy, hence the emotions and the field of references of the theme are inseparate from the colours and forms in the picture.

If painting is merely a process and nothing but an arrangement of colours, forms and textures for their own sake, then the artist becomes a mere manufacturer of visual confectionery. If the subject in a painting is unimportant, we may well ask unimportant to whom? The subject unimportant to Fra Angelico? The themes and subjects unimportant to the builders of Chartres Cathedral? the subject unimportant to Rembrandt?

The terms 'pure painting', 'pure art' seem to me to be meaningless. In the experience of painting as I have found it, colours and forms are instrumental, and I hold the view that pictures are stations of trans-missions, and painting a metaphysical activity.

There was a time when Artists were employed to create and set up altars to the gods of Life in civilizations that were temples, and deep within us we Artists must endeavour to remember the services we were once able to give to humanity and to man's deepest experience of reality. To remember this, is to understand why we feel exiles.

Beneath our technological civilization, there still flows the living river of

human consciousness within which is concentrated in continuity the life of the kingdoms of animals, plants, stars, the earth and the sea, and the life of our ancestors, the flowing generations of men and women: the sensitive and the solitary ones, the secret inarticulate longing before the mystery of life. The artist is a vehicle of the continuity of that life and his instrument is the myth and the archetypal image.

The seeing of things, and the seeing into things.

Art is concerned with the transformation of consciousness.

A picture is a figuration of Being.

Imagination is the organ of the interior nature.

The Imagination searches out and prefigures the mysterious unity of all life.

Art is a point of interpenetration between worlds, as a marriage of the known with the unknown, for it is the unknown that freshens our life. In Art we can converse with that abundant life whose energy glows through the sad terrestrial curtain of time.

The Reality of life is incomprehensible, and the Artist creates an incomprehensible image of it.

Art sets free an instant of vision, things seen in their archetypal essence in the sacrament of image and colour.

All art is an attempt to manifest the Face of the God of Life. The sky of our time has been lit from the beginning of childhood by the light of the Apocalypse; always before our eyes have ridden the four horsemen.

Vision is to awaken man's real self, for in Art there is a hidden inviolate instinct for freedom, for eternity. Just as it is necessary to have a language for explicit experience that can be measured, analysed and described, so it is necessary to have a language for implicit experience which cannot be analysed or measured because it cannot be described. This is the inner life of the soul, and the implicit language of the heart and the soul is poetry, the image, the symbol, dance, music and silence. Implicit vision is transmitted by evocation; knowledge and vision as atmosphere. So the image symbol is an evocation in the soul of the fragrance and atmosphere of its life and destiny. This is exactly opposite to a code language where, when you have cracked the code, you have got the answer. This is a banality to the soul and the human heart.

When the Image speaks in silence, words cease.

There is a growing awareness that modern culture is approaching a severe crisis and that sooner or later it will have to undergo a ruthless revaluation. That revaluation must reveal the cause of the disorientation of contemporary culture which for so long now has been made a virtue of, or has been accepted without intelligent criticism or questioning. This

revaluation will quicken the realisation of the necessity to focus man's consciousness upon the creative centre of Life, which the great cultures of the world have named the Sacred. And with all its urgency, it is in this act of orientation towards the Sacred centre of Life that contemporary culture will find confirmation of that universal Reality, the rediscovery of which, alone, will save our civilization.

I do not believe in surrealism, precisely because I do believe in a surreality, universal and eternal, above and beyond the world of the intellect and the senses; but not beyond the reach of the humility and hunger of the human heart. And the human heart will find no meaning in life until it returns to eat of the source from which it came; and that source is the Eternal Person of all persons – God. For there is no meaning in life or art excepting that which springs from the immortal surreality of that Eternal Person.

The Saint, the Artist, the Poet, and the Fool, are one. They are the eternal virginity of spirit, which in the dark winter of the world, continually proclaims the existence of a new life, gives faithful promise of the spring of an invisible Kingdom, and the coming of light.

Je me mire et me vois Ange! et je meurs et j'aime
– Que la vitre soit l'art, soit la mysticité
A renaître, portant mon rêve en diadème,
Au ciel antérieur où fleurit la beauté!

Mallarmé

I look at myself in the mirror and I see an Angel! and I die and I love.
– May that mirror be art, be the mystical nature –
Born again, bearing my dream in a diadem,
To that former heaven where Beauty flowered.

Mallarmé

A work of Art can be thought of as pure form, but the fact is that it cannot be created as pure form.

<div align="right">*Wladimir Weidle*</div>

Artists are attached to their time by their weakness,
Not by their strength.

<div align="right">*Goethe*</div>

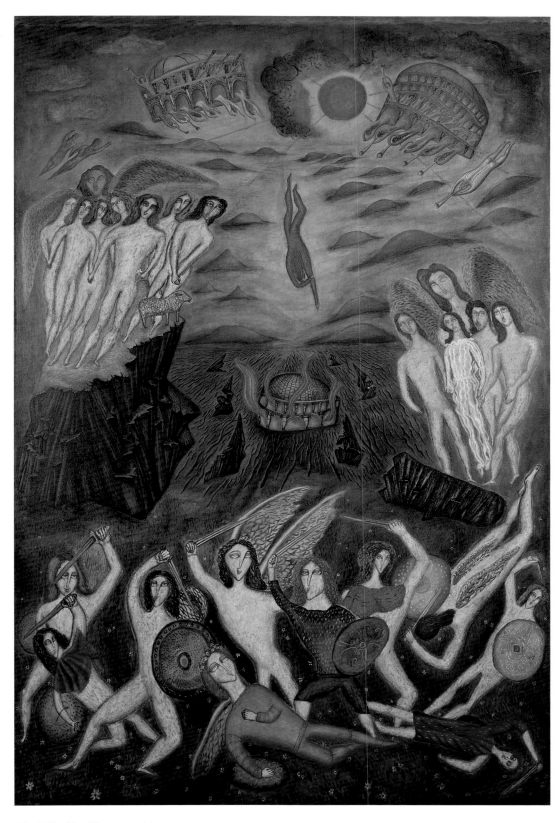

The Fall of Lucifer 1933 (4)

The Cells of Night 1934 (5)

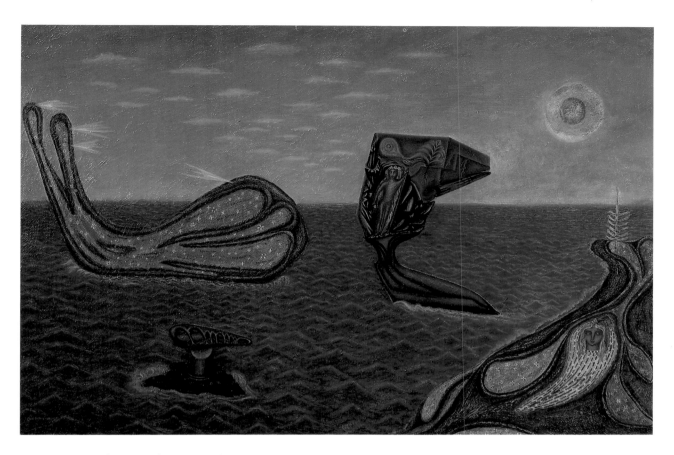

Virgin Images in the Magical Processes of Time 1935 (9)

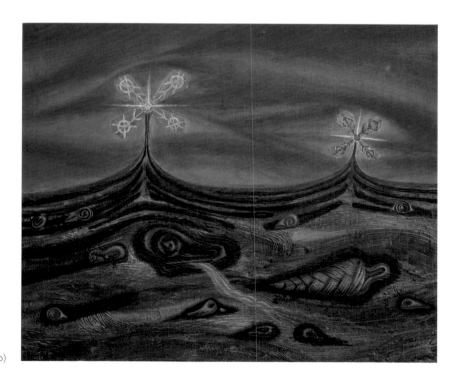

The Promise 1936 (10)

The Voice 1938 (13)

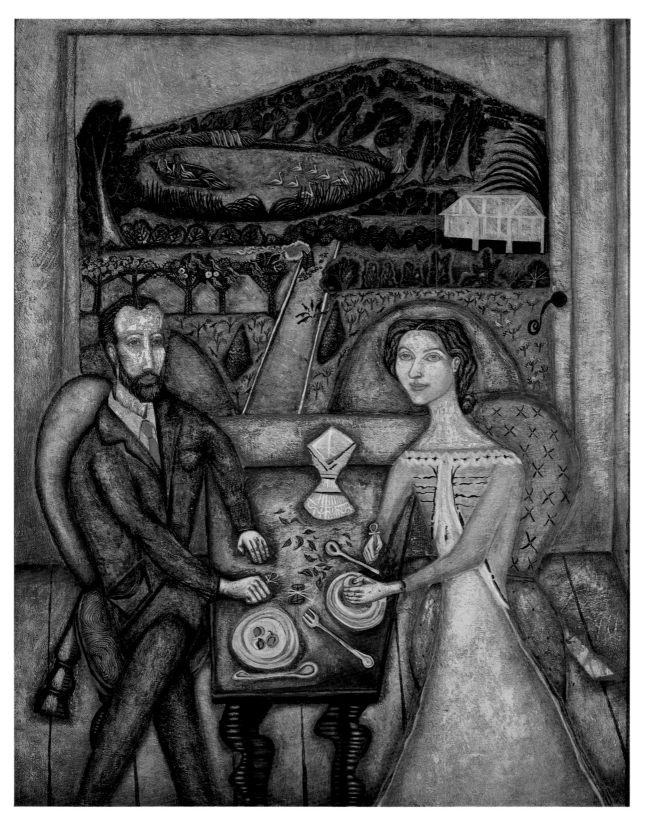

The Artist and his Wife 1939 (15)

Landscape with Hills and River 1943 (21)

The Sleeping Fool 1943 (24)

Landscape: Sunrise 1949 (28)

Hymn to Night 1951 (31)

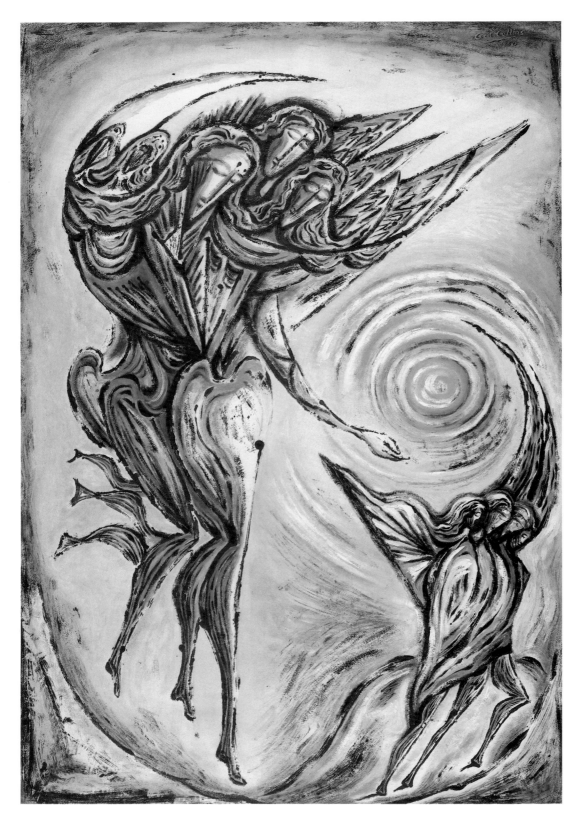

Angels Dancing with the Sun and the Moon 1949 (29)

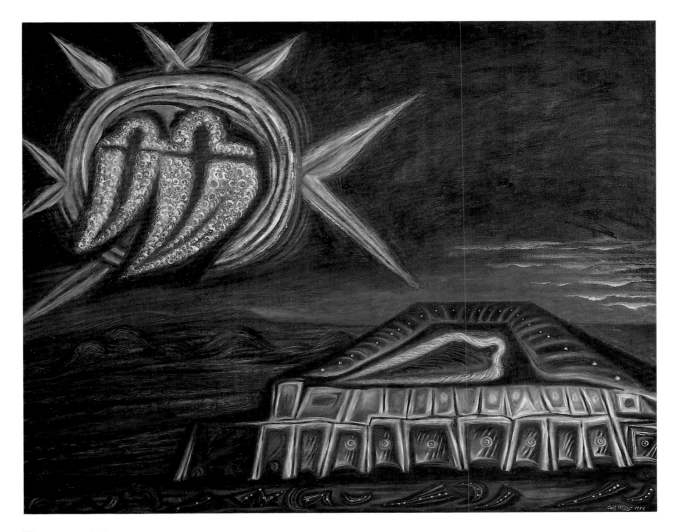

Hymn 1953 (33)

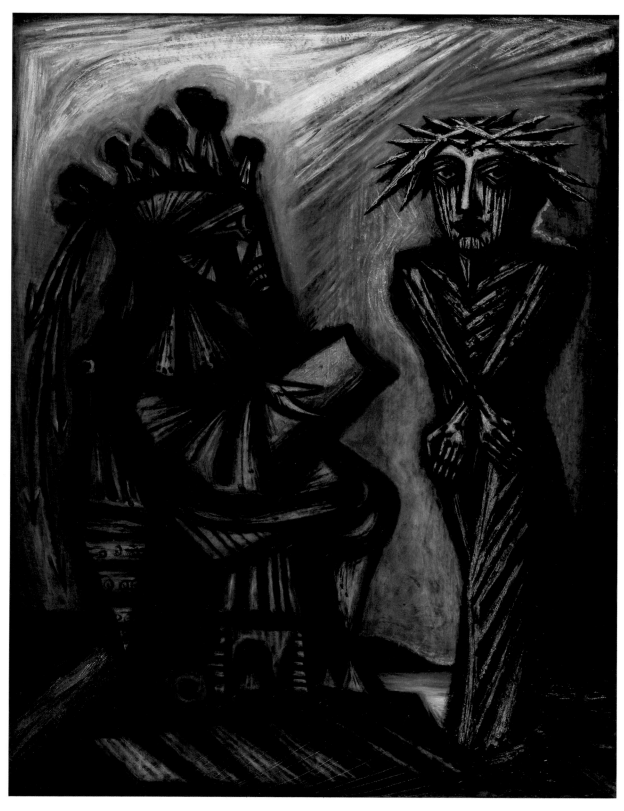

Christ Before the Judge 1954, reworked 1956 (34)

Landscape: Autumn 1958 (38)

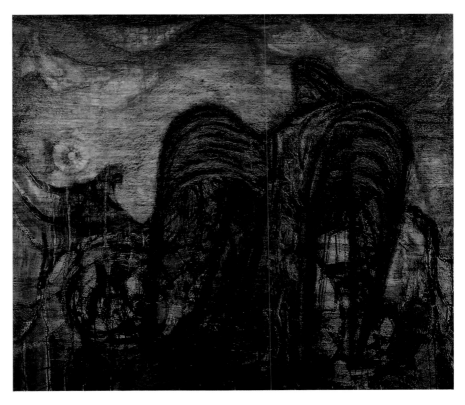

The Guardian of Paradise 1963 (42)

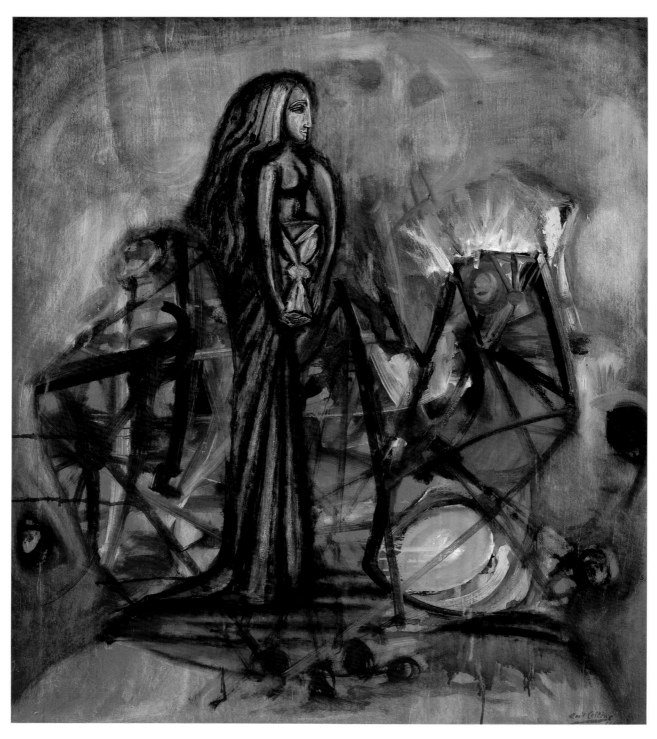

The Eternal Bride 1963 (43)

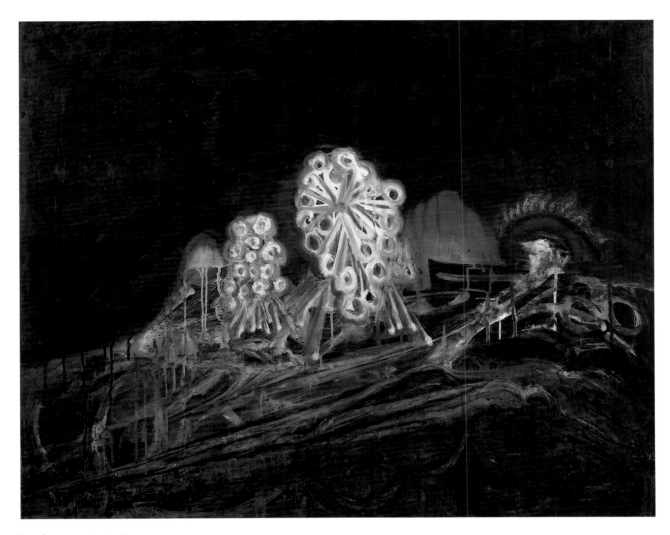

Landscape 1965 (46)

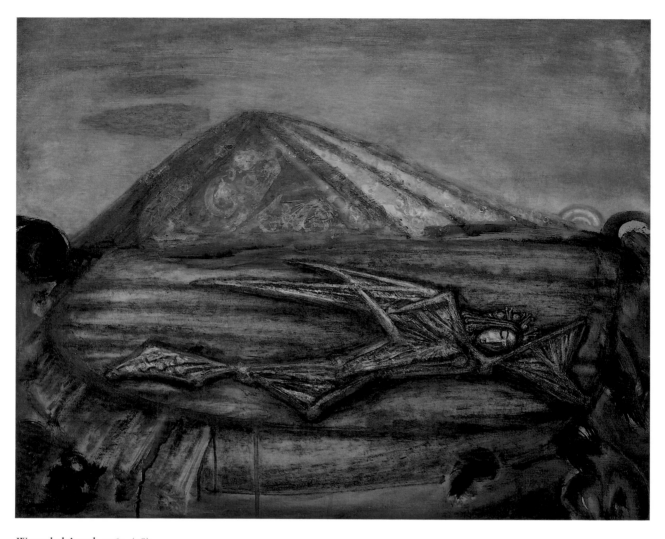

Wounded Angel 1967 (48)

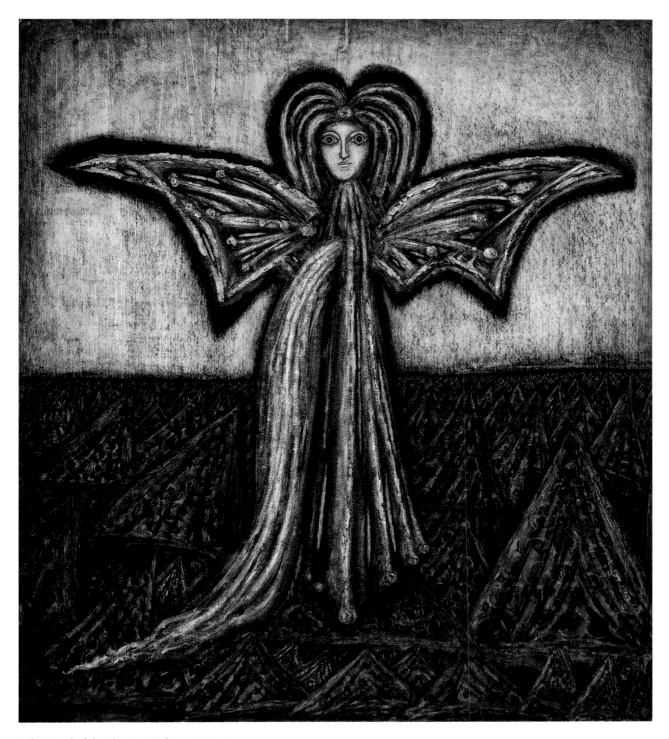

The Angel of the Flowing Light 1968 (49)

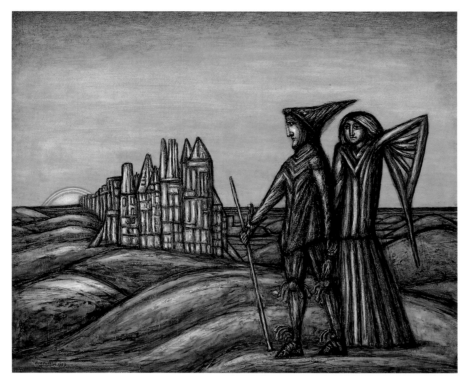

Fool and Angel Entering a City
1969 (50)

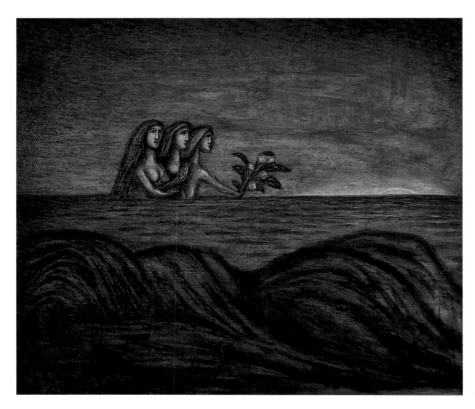

Daybreak 1971 (52)

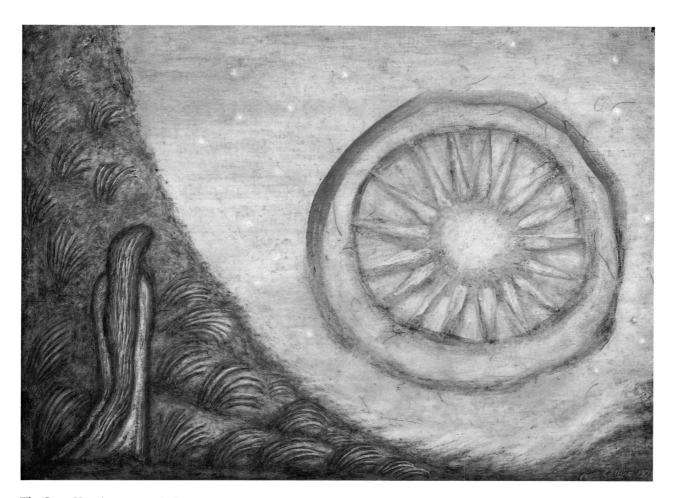

The Great Happiness 1974 (53)

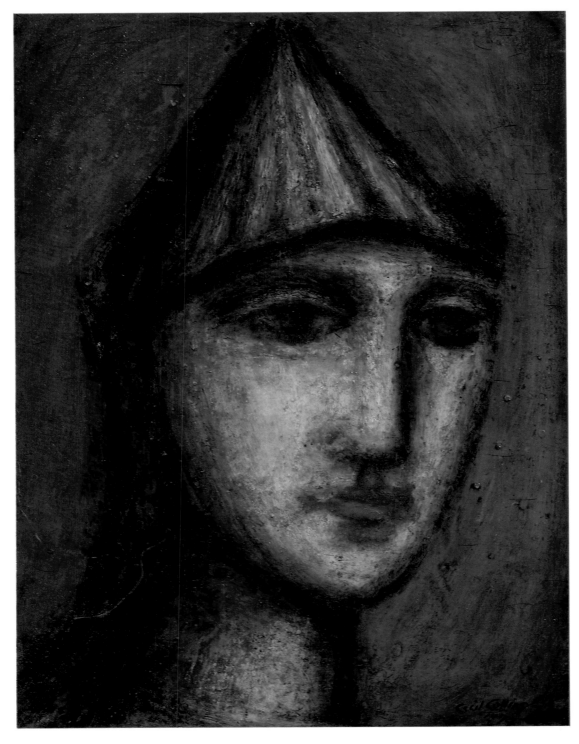

Head of a Fool 1974 (54)

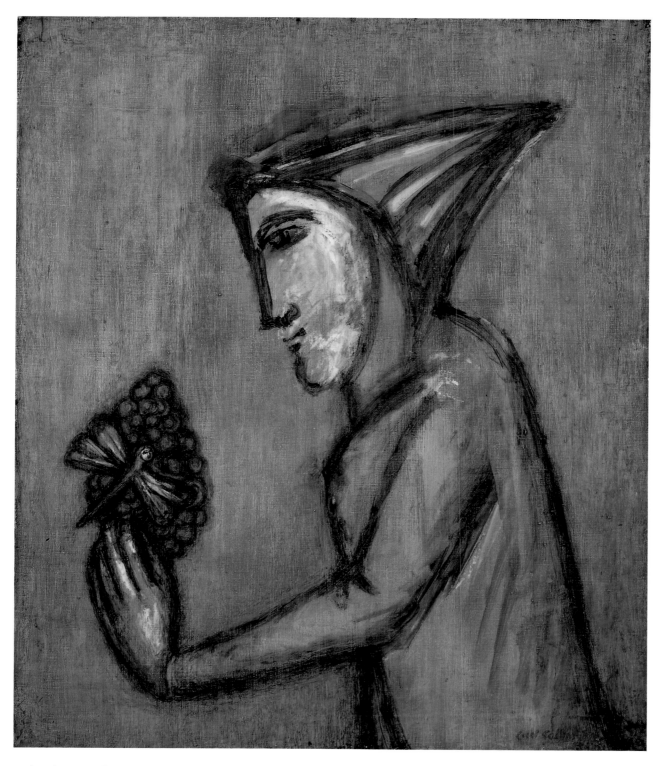

Fool with a Butterfly 1985 (57)

Walking on the Waters 1986 (59)

The Music of Dawn 1988 (65)

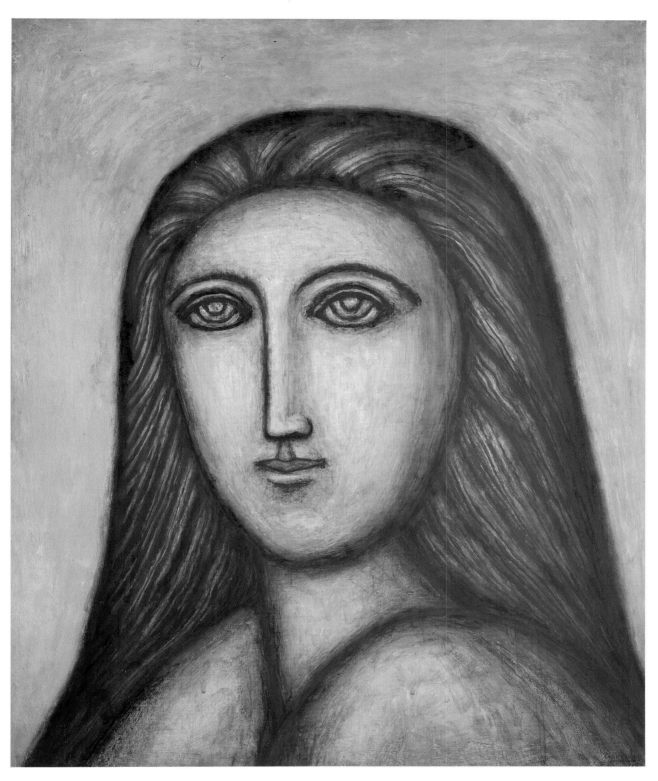

Head of an Angel 1987 (60)

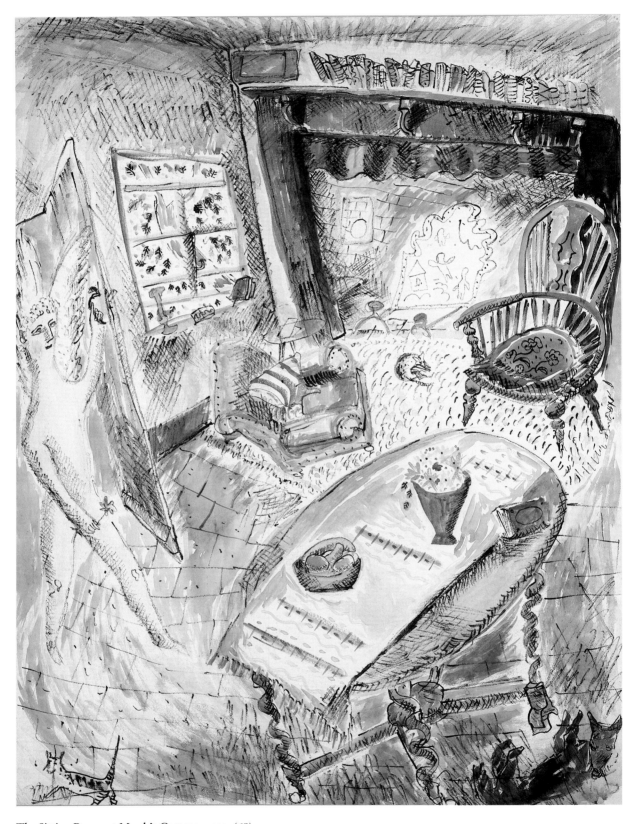

The Sitting Room at Monk's Cottage 1932 (68)

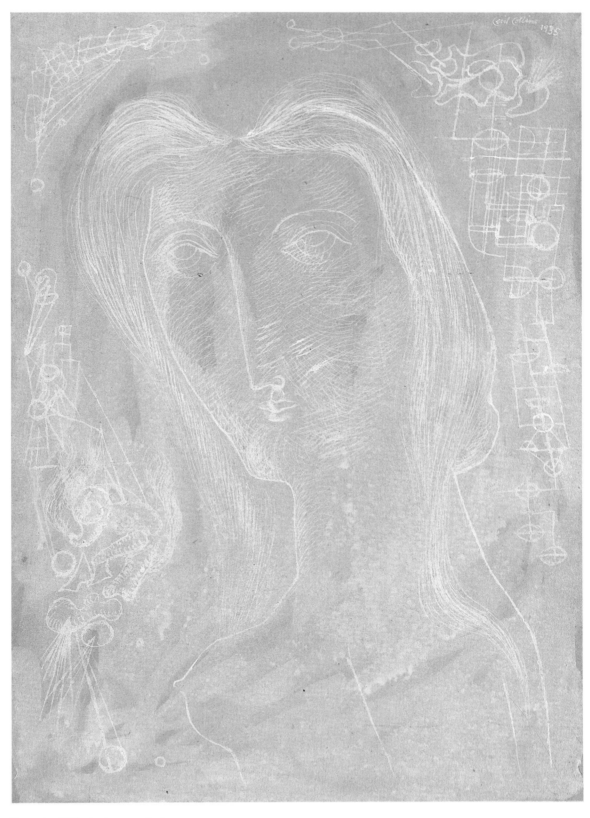

Portrait of Elisabeth 1935 (75)

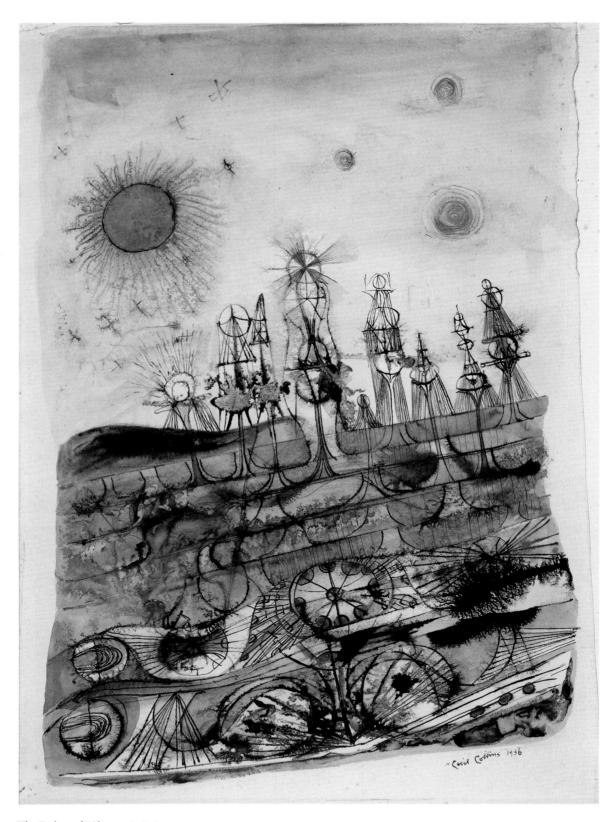

The Robes of Life 1936 (80)

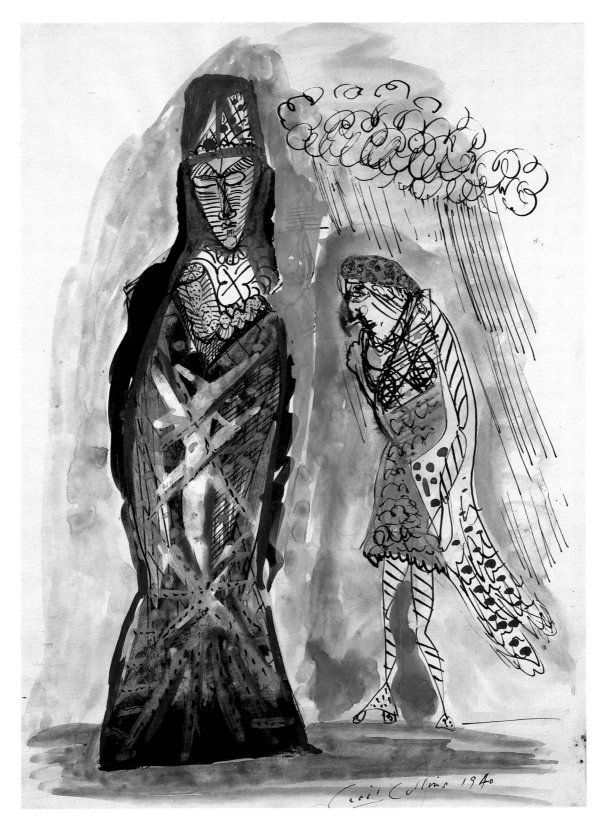

Fool Picking his Nose in Front of a Bishop 1940 (91)

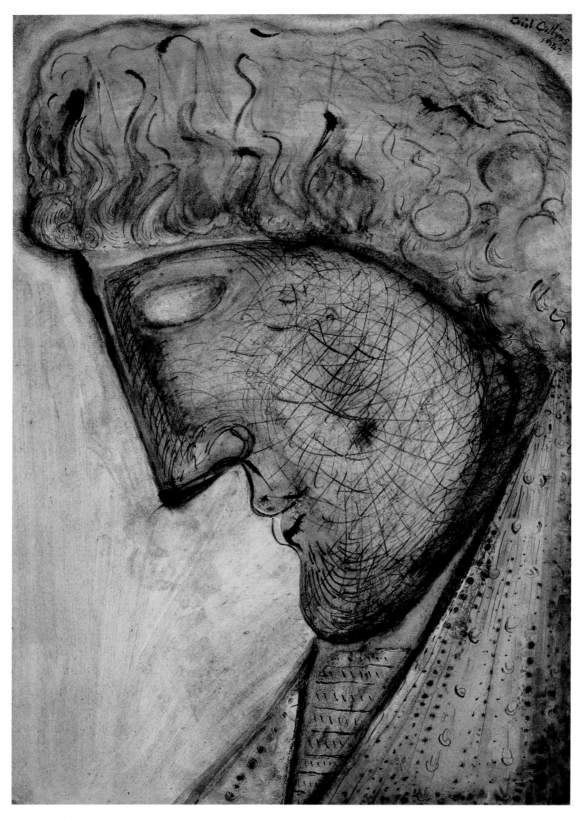

Man in Meditation 1942 (92)

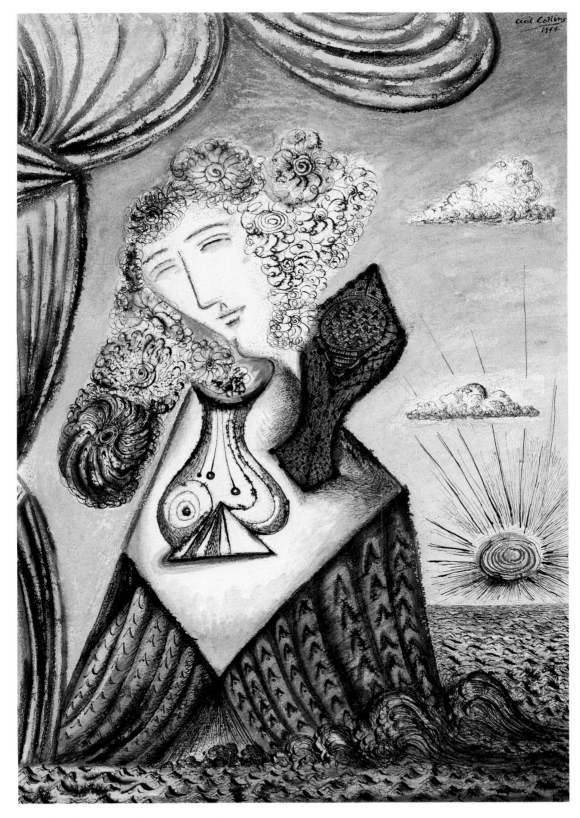

Still Life, The Coming of Day 1944 (108)

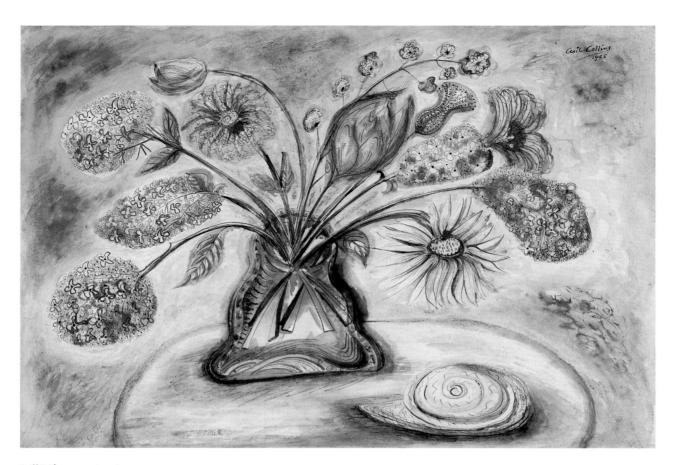

Still Life 1945 (113)

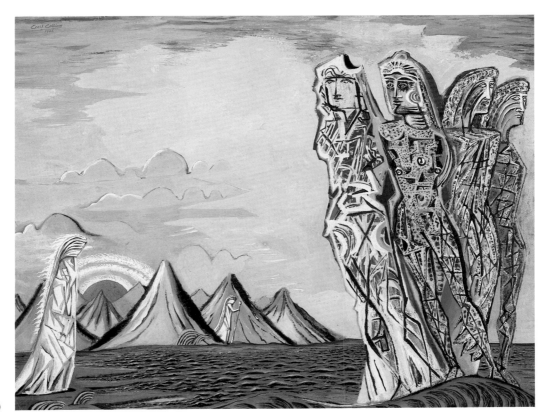

Hymn 1946 (117)

Landscape: Moonlight 1947 (119)

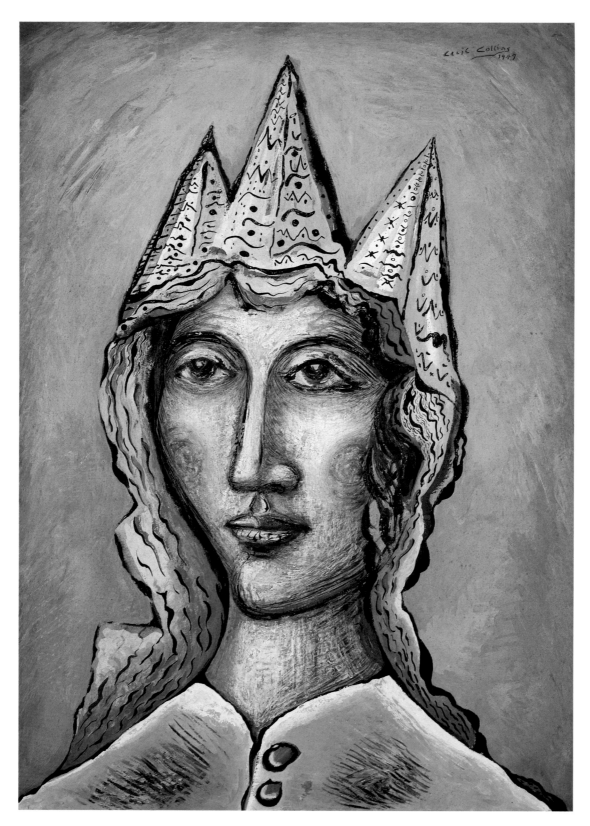

Head of a Fool 1949 (121)

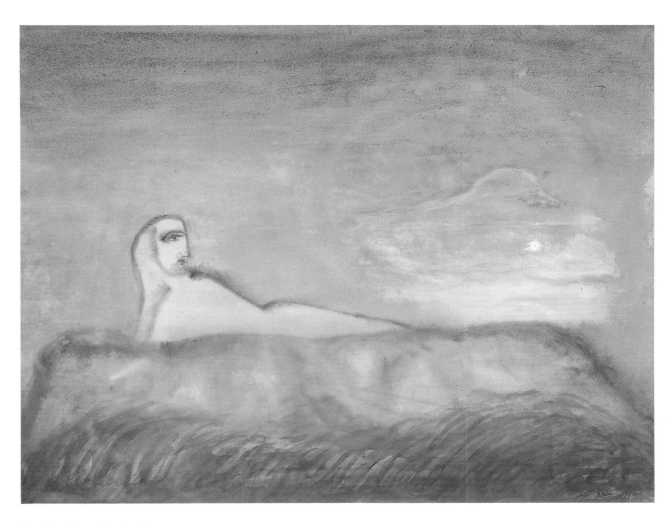

Morning Star 1981 (143)

Catalogue

All known titles are included in the catalogue entries. Measurements are given in inches followed by centimetres, with height preceding width. The exhibition history is not exhaustive; this is because many paintings have paper exhibition labels written by the artist stuck on top of each other, obscuring the previous one. All exhibitions have London venues unless otherwise stated. Certain abbreviations have been used in the entries and these are listed below:

Anderson Anderson, William. *Cecil Collins: the quest for the Great Happiness*. London, 1988

BC British Council

b.l. bottom left

b.r. bottom right

CAS Contemporary Art Society

CC Comfort, Alex. *Cecil Collins: paintings and drawings 1935-45*. Oxford, 1946

CC Prints *The prints of Cecil Collins*. Catalogue by Richard Morphet. London, Tate Gallery, August–November 1981.

EXH: exhibited

LIT: literature

RCA Royal College of Art

REPR: reproduced

The full details of Collins's one-man exhibitions, which are referred to in abbreviated form in the catalogue, can be found in the exhibition listings in the Bibliography.

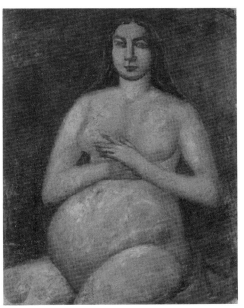

1 **Maternity** 1929
 Oil on cardboard 48 × 36 (122 × 91.5)
 Inscribed: 'Cecil Collins/19[...]. b.r. and
 'FORBEARE/MOTHER OF MAN/WITHER' on
 back
 EXH: Whitechapel 1959 (2); *Exhibition Road,
 Painters at the Royal College of Art*, RCA, 1988
 (40, repr p.146)
 REPR: Anderson, pl.9
 Private Collection

An imaginative composition painted in the artist's bed-sitting room on the top floor of a lodging house in Gunter Grove, and carried into college when completed. Submitted to an exhibition of RCA student work at the V&A Museum in 1930 and rejected by RCA staff on the grounds that its subject matter would offend the museum visitors.

2 **Portrait of Elisabeth in a Blue Dress** 1931
 Oil on canvas 29½ × 20 (75 × 51)
 Inscribed: '1931/COLLINS' b.r. and 'Cecil
 Collins/1931' on back
 Not previously exhibited
 REPR: Anderson, pl.11
 Private Collection

Painted from life shortly after their marriage. Elisabeth wears a blue dress covered with red stars. The pose of her hands crossed below the breasts, or over the heart, echoes that of the female figure in 'Maternity'. Her left hand bears her new golden wedding ring.

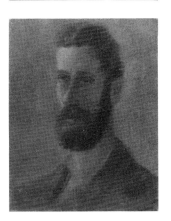

3 **Self-portrait** 1932
 Oil on rough canvas 20 × 15 (50.8 × 38.2)
 Inscribed: '1932/Collins' b.r. and 'Self-portrait/Cecil Collins/1932' on back
 Not previously exhibited
 Private Collection

Besides another self-portrait in oils, painted contemporaneously in a looser style and in brighter colours, there are only two other self-portraits by the artist and both of these are works on paper. One is a roneo print of 1944 and the other was drawn in ink at the request of the Art News and Review in 1949.

4 **The Fall of Lucifer** 1933
 Oil on canvas 108 × 72 (273 × 180)
 Inscribed: 'Cecil Collins 1933' b.l. and 'The Holy
 War/Cecil Collins/1933' on back
 EXH: Bloomsbury Gallery 1935 (20); Barn Studio,
 Dartington 1937 (15); Whitechapel 1959 (4)
 REPR: Anderson, col.pl.19
 Private Collection

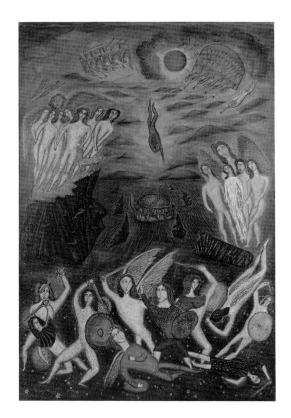

Painted in summer 1933 in a wooden garden shed
outside Monk's Cottage. The wooden shed was ordered
by post specifically as a painting studio; it arrived in
sections and had to be assembled. The tall canvas only
just fitted into it. Collins had to paint some of it using a
ladder. Wasps nested in the roof of the shed level with
his head when painting the top of the canvas. He was
stung by a wasp while painting, and he felt this to be a
deliberately provocative act on the part of the insect.
Although Collins was attempting to live by Buddhist
principles and to cause no harm to any living creature,
he was compelled, for the sake of the painting, to attack
the wasps with fumes. He watched as the wasps fell to
earth in front of the fall of the rebel angel to hell. The
canvas was taken off its stretcher and rolled up after its
showing at the Whitechapel in 1959. It has been newly
restored for this exhibition. First great example of the
artist's main theme, the loss of Paradise.

5 **The Cells of Night** 1934
 Oil on canvas 30 × 25 (76 × 63.5)
 Inscribed: 'the Cells of Night/Cecil
 Collins/1934/Painting 3' on back
 EXH: Bloomsbury Gallery 1935 (4); Barn Studio,
 Dartington 1937 (5); *Britain's Contribution to
 Surrealism*, Hamet Gallery, 1971 (22); CC Prints,
 Tate, 1981 (i)
 LIT: *The Tate Gallery 1970–72: biennial report*,
 pp.93–5
 REPR: *The Tate Gallery 1970–72*, p.93;
 Anderson, col.pl.22
 Tate Gallery

Painted at 52 Redcliffe Road, London. This painting
conveys a nocturnal, lunar atmosphere. The paint of the
craters is built up in relief, and the surface is scratched
between them.

6 A Song 1934
Oil on canvas 19¾ × 28¼ (50 × 74)
Inscribed: 'Cecil Collins/1934' b.r. and 'Cecil
Collins/April 1934/a song' on back
EXH: Bloomsbury Gallery 1935 (5); Ashmolean
Museum, Oxford 1953 (23); Whitechapel 1959 (7)
REPR: Anderson, col.pl.20
Private Collection

Painted at Monk's Cottage. An example of a richly
textured lead white oil ground as underpainting. First
appearance of seashells, which relate to memories of the
artist's early days at the seaside.

7 The Eternal Journey 1934
Oil on canvas 19¾ × 28¼ (50 × 74)
Inscribed: 'Cecil Collins/1934' b.l. and 'Cecil
Collins/1934/painting 12/Archegenesis' on back
EXH: Bloomsbury Gallery 1935 (6 as
'Archegenesis'); Whitechapel 1959 (6); *British Art
and the Modern Movement* 1930–40, Cardiff, 1962
(99)
REPR: Anderson, col.pl.22
Private Collection

This is the first example of the other great theme of
Collins, that of the journey of the individual soul, at
whose end is the hope of Paradise regained. The
landscape is that of an embryonic world fed by a river of
light. At lower left three mummified chrysalis forms
await transformation. An embryonic angel form floats
above. Imagery from current scientific knowledge has
been used in the veined mummified form.

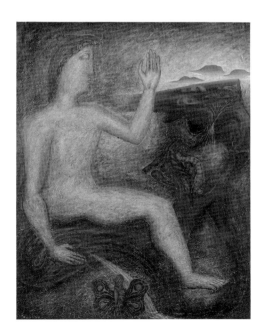

8 The Poet: Image with Forms 1935
Oil on canvas 47 × 36 (130 × 102)
Inscribed: 'Cecil Collins/1935' b.l. and 'Image
with Forms/Cecil Collins/April 1935' on back
EXH: Bloomsbury Gallery 1935 (17 as 'Image with
Forms'); Whitechapel 1959 (9 as 'The Poet', with
dimensions reversed); *British Art and the Modern
Movement*, 1930–40, Cardiff, 1962 (100, repr.
p.29); *A Paradise Lost*, Barbican, 1987 (42 as 'The
Poet')
REPR: Anderson, pl.18
Private Collection

Painted at 52 Redcliffe Road, London. An oracular
figure sits in a dark landscape. Bones lie on the ground in
the distance, while a butterfly, symbol of transform-
ation, rests near to the poet's hand.

9 **Virgin Images in the Magical Processes of
Time** 1935
Oil on wood 29 × 45 (74 × 114)
Inscribed: 'Cecil Collins 1935' b.l., 'Resurrection'
in capital letters eleven times inside the left-hand
shape and with title and date of 'July 1935' on
back
EXH: *The International Surrealist Exhibition*,
New Burlington Galleries 1936 (58); Barn Studio,
Dartington 1937 (14); *Yorkshire Artists'
Exhibition*, Leeds City Art Gallery 1939 (7); *Dada
and Surrealism Reviewed*, Hayward Gallery, 1978
(14.9, repr. p.359); Plymouth 1983 (1); *Surrealism
in Britain in the Thirties*, Leeds, 1986 (146, repr.
p.170)
REPR: Anderson, col.pl.16
Private Collection

Four forms are adrift on a blue wavy sea. One in the
background on the left has a flowery interior and the
word Resurrection eleven times randomly scattered
inside the shape. Four rays issue from the upper parts of
the form. The shape in the foreground on the left
consists of a seashell on a pedestal. The shape in the
foreground on the right contains flowery areas and an
angelic figure in a patterned robe, with blonde hair, and
her arms raised over her head. The shape in the
background on the right contains a naked pilgrim figure,
with a staff and full-length hair, like the figure in 'Images
in Praise of the Love' 1936 (cat.no.11).

10 **The Promise** 1936
Oil on plywood 20 × 24 (51 × 61)
Inscribed: 'Cecil Collins/1936' b.l.
EXH: Barn Studio, Dartington 1937 (24); *Britain's
Contribution to Surrealism*, Hamet, 1971 (25);
Hamet Gallery 1972 (1); CC Prints, Tate, 1981 (ii)
LIT: *The Tate Gallery 1972–74; biennial report
and illustrated catalogue of acquisitions*, 1975,
pp.109–110
REPR: *The Tate Gallery 1972–74*, 1975, pp.109;
Anderson, pl.98
Tate Gallery

Painted at Monk's Cottage. The setting is the world
before birth, at night-time; the promise is that of birth
and a dawning to come. The site is a seashore – seeds,
shells and chrysalises lie in the earth. Two manifest-
ations of energy burst forth from the surface of the earth,
and these are formed like flowers. Collins used to watch
the beam of the Eddystone lighthouse off the Devon
coast as a child, and these flower-like forms are a
reminiscence of that experience.

11 **Images in Praise of the Love** 1936
Oil on canvas 29½ × 19¾ (75 × 50)
Inscribed: 'Cecil Collins/1936' b.l. and 'Images in Praise of the Love/Cecil Collins/1936' on back
EXH: Barn Studio, Dartington 1937 (23); *Britain's Contribution to Surrealism*, Hamet, 1971 (24)
REPR: Anderson, col.pl.23
Private Collection

Painted at Springhill. A work produced in opposition to the standpoint of the Surrealist artists, who Collins believes 'broke down the world. You don't need an artist to kick you in the bottom, life does that.' This painting is an attempt at reconstituting the world. It brings together the life forms of the universe. In the centre is the astronomical form (a direct copy of the planet Jupiter); to the lower left of this planet is the angelic form with lines radiating out from the heart; a human form (the human psyche or soul) is seen holding on to a tree and is in the act of rising upwards; biological forms are found around the edge of the central form; cellular 'fairy' treasures are hidden in the earth at bottom left and right. The whole canvas is punctuated with vertical scratched lines, made with an etching needle, to create a kind of vibration for the painting. The white paint is 'threshed with a needle', as in the 'Cells of Night' (cat.no.5).

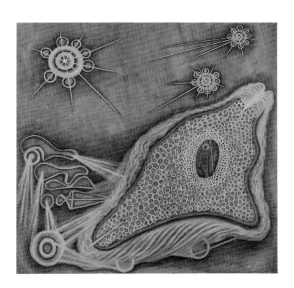

12 **The Joy of the Worlds** 1937
Oil on wood 50 × 50 (127 × 127)
Inscribed: 'Cecil Collins/1937' b.r.
EXH: Whitechapel 1959 (15)
REPR: Anderson, col.pl.89
Private Collection

Painted in the front room at Swan Cottage, Totnes. The pilgrim with staff and light-haloed head stands in the centre of a cellular filled womb, from the top of which light/water streams. Above him, planets move in their courses and give off the music of the spheres. It is rare for Collins to use green as he does here.

13 **The Voice** 1938
Oil on canvas 48 × 60 (122 × 152)
Inscribed: 'Cecil Collins 1938' b.r. and with the words 'HOLY, HOLY, HOLY ETERNAL-O DEATH O LIFE' in red on the uppermost rock at the left
EXH: Leicester Galleries 1956 (13); Whitechapel 1959 (16); *Britain's Contribution to Surrealism*, Hamet, 1971 (26); *A Paradise Lost*, Barbican, 1987 (46)
REPR: *The Painter and Sculptor*, vol.1, no.1, Spring 1958, p.25; Anderson, col.pl.94
Mr & Mrs Thomas E. Worrell, Jr

This work was bought directly from the artist by an

American collector, Carroll Donner. On her death it was left with the Santa Barbara Museum, California who then sent it off for sale at the behest of her family, not knowing of the artist. The artist has said 'There is only one voice in the universe. We do not even own our own voices.' The serene profile head could be responsible for the voice, or be the one who hears it.

14 The Quest 1938

Oil on canvas 43 × 57 (109.2 × 144.8)
Inscribed: 'Cecil Collins 1938' b.r. and 'Cecil Collins/1938 Autumn' on back
EXH: Heffer Gallery Cambridge 1950 (20);
Leicester Galleries 1951 (27); *Yorkshire Artists'*
Exhibition, Leeds City Art Gallery, 1955 (187);
AIA 25th Exhibition, RBA Galleries, 1958 (28);
Whitechapel 1959 (17, repr. pl.I); *Thirties*,
Hayward Gallery 1980 (6.14); *A Paradise Lost*,
Barbican 1987 (45)
REPR: Anderson, col.pl.92
Private Collection

Painted in autumn 1938 in about three weeks in a rented holiday cottage at Torcross on the coast, overlooking Slapton Sands, in Start Bay, Devon. The painting was transported back to Totnes where the Collinses then lived, on the roof-rack of a car belonging to Bernard Leach, the potter. The landscape is inspired both by the inland lake trapped by sands at Slapton Sands and by lantern slides of Arctic wastes, from a lecture given at Dartington during which Collins fell asleep and awoke to find himself looking at an image of an iceberg. The painting is concerned with the idea of the waste land and the search for the grail. The crowned figure in the boat is the solitary king of Eliot's Waste Land. Collins was reading Eliot in the 1930s. It is this King's quest. The two men with sticks are his guardians. The king has his left arm across his chest in a gesture of power.

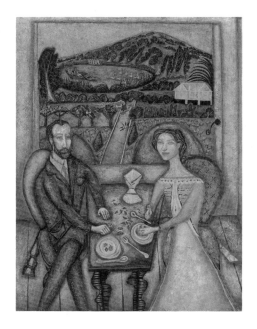

15 The Artist and His Wife 1939

Oil on canvas 47¼ × 35½ (120 × 90)
Inscribed: 'Cecil Collins/1939' b.l. and 'The Artist and his Wife/Cecil Collins/1939' on back
EXH: *Panorama*, Barn Studio Dartington 1940 (3);
Lefevre 1944 (16); Heffer Gallery, Cambridge 1949
(66); Whitechapel 1959 (21); Hamet Gallery 1972
(2); *Thirties*, Hayward Gallery 1980 (6.13, repr.
p.165); *A Paradise Lost*, Barbican 1987 (47, repr.
pl.8 in col.)
REPR: *CC* 1946, p.22; *World Review*, Sept 1950,
between pp.32–3; *Resurgence*, May–June 1988,
no.128, p.29 in col.; Anderson, col.pl.29
Private Collection

Painted at Swan Cottage, Weirfields, Totnes, Devon. Swan Cottage is a small bungalow close to the river Dart, just where the river is punctuated by a weir. Swans were a prominent feature of the river life there. Collins is wearing a green suit in this painting, and the colour is not just artistic licence. Collins actually had a suit made from cloth woven in Scotland and coloured green with vegetable dyes. It made him into a veritable 'Green Man' during his Dartington period. The suit lasted well into his Cambridge period (and he still has a bit of it left today).

16 Dawn 1939
Oil on canvas $7\frac{1}{4} \times 9\frac{3}{4}$ (17.5 × 25)
Inscribed: 'Cecil Collins 1939' b.r. and 'Cecil
Collins/1939/MEMORY' on back
EXH: *A Paradise Lost*, Barbican 1987 (48, repr.
p.14 in col.)
REPR: Anderson, col.pl.31
Private Collection

The table, placed in front of a mountain range, and amid stony ground, is laid with a white cloth and set with two chalices and an ankh. The ankh hieroglyph in Egyptian means 'life which cannot die'. Cecil and Elisabeth Collins hold ankhs in their hands in 'The Artist and His Wife' (cat.no.15). The artist feels that tables draped with cloths are like altars.

17 Landscape: The Approach 1940
Oil on canvas 20 × 24 (51 × 61)
Inscribed: 'Cecil Collins 1940' b.l.
EXH: *Contemporary British Art*, BC tour to USA
1942 (16, repr.); Heffer Gallery, Cambridge 1950
(21); Whitechapel 1959 (22); CC Prints, Tate 1981
(iii)
REPR: BC catalogue, p.46
Private Collection

This painting relates to two etchings entitled 'Landscape' executed in 1939, (both were exhibited and reproduced in CC Prints, Tate, 1981, nos 5 & 6). The etchings and this painting show a desert wilderness which the pilgrim must traverse. His staff lies on the ground, and a raised causeway indicates the path he must take. Bones and stones litter the ground. Large towers are visible against the horizon.

18 The Poet 1941
Oil on canvas $29\frac{5}{8} \times 19\frac{3}{4}$ (75.3 × 50.2)
Inscribed: 'Cecil Collins/1941' b.l. and 'The
Poet/1941/Cecil Collins' on back
EXH: *Britain's Contribution to Surrealism*,
Hamet, 1971 (27, repr. [p.13])
REPR: Anderson, col.pl.115
Private Collection

This is related to the pilgrim (see cat.nos.70 and 71), where the figure is bounded by a linear frame. The sun's rays are causing a dead tree to return to life. As with 'The Pilgrim Fool' (cat.no.19), a city burns in the background.

19 The Pilgrim Fool 1943
Oil on canvas 15 × 9 (39.5 × 24)
Inscribed: 'Cecil Collins 1943' b.r.
EXH: Lefevre 1944 (2); Whitechapel 1959 (32); CC
Prints, Tate, 1981 (viii); *A Paradise Lost*, Barbican
1987 (54, repr. pl.13)
REPR: *Horizon*, Feb 1944, between pp.116–7; *The
Vision of the Fool*, 1947, col.pl.2; *World Review*,
Sept 1950, between pp.32–3; *The Vision of the
Fool*, 1981, col.pl.1; Anderson, pl.33
Private Collection

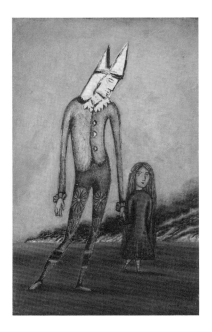

This is the first work in which the Pilgrim and the Fool
are conflated into one figure. This figure looks more like
a Fool because of his costume, but in his role as pilgrim
he leads a small long-haired child across an area of flat
land, in the background of which a city is burning. This
burning city refers in part to Collins's own home town of
Plymouth, badly bombed at this time. The female child
is his own soul, his anima, the most valuable of his
possessions which he is saving from the destruction and
violence in the distance, and similar in appearance to
Alice in Wonderland. The shell, on his hose, is the
symbol of the pilgrim.

20 The Return 1943
Oil on canvas 9⅝ × 13 (24.5 × 33)
Inscribed: 'Cecil Collins/1943' on back
EXH: Lefevre 1944 (10); Whitechapel 1959 (30)
REPR: CC 1946 p.42; Anderson, col.pl.117
Mary Fedden

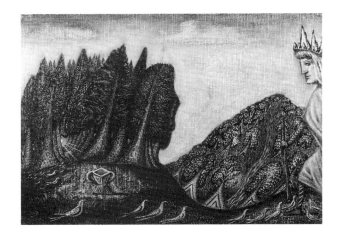

Collins's friend Julian Trevelyan owned this work by
1946 when it was reproduced for the first time. A king-
pilgrim-fool figure enters from the right into a fertile
landscape. A red chalice is set on the ground and the sun
shines down an avenue of fir trees. The weary pilgrim-
fool figure who returns can be likened to Wagner's
Parsifal, who in Act III comes back to the place where he
started from, having gained from his experiences in the
meantime.

21 Landscape with Hills and River 1943
Oil on canvas 20 × 30 (50.8 × 76.2)
Inscribed: 'Cecil Collins/1943' b.r.
EXH: ? Lefevre 1944 (15-Landscape); Plymouth
1983 (3); Aldeburgh 1984 (no number)
REPR: Anderson, col.pl.39
Sir Michael Culme-Seymour

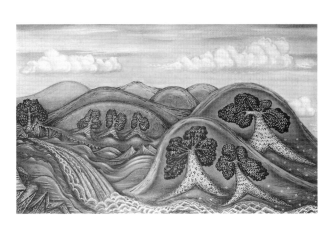

This is the first pure landscape in Collins's oeuvre. It
relates topographically to the hills and the River Dart
around the Dartington estate.

22 The Greeting 1943
Oil on canvas 10 × 7 (25.4 × 17.8)
Inscribed: 'Cecil Collins 1943' b.r.
EXH: Lefevre 1944 (11); Whitechapel 1959 (25)
REPR: CC 1946, col.pl.2
Peter Nahum, London

The first owner of this work was Mrs H.N.Brailsford.
The single robed figure appears to be greeting the sun.
For a similar composition, see 'The Great Happiness'
(cat.no.53).

23 The Happy Hour 1943
Oil on canvas 10 × 7 (25.4 × 18.8)
Inscribed: 'Cecil Collins 1943' b.r.
EXH: Lefevre 1944 (3); Whitechapel 1959 (36);
Plymouth 1983 (2, repr. [p.16]); Aldeburgh 1984
(no number); *Temenos Exhibition*, Dartington
1986 (no number)
REPR: *The Vision of the Fool*, 1981, pl.1;
Anderson, pl.105
Dartington Hall Trust

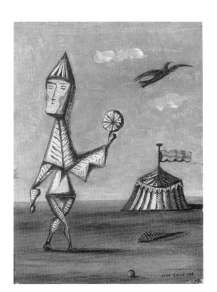

A fool with a wheel (of fortune?) stands in a barren land,
in front of a patterned tent. The bony skeleton of a fish
lies on the ground to his left. For a fish on a plate, see
'The Bride' (cat.no.95).

24 The Sleeping Fool 1943
Oil on canvas 11¾ × 15¾ (29.8 × 40)
Inscribed: 'Cecil Collins 1943' b.r.
EXH: Lefevre 1944 (5); *Contemporary British Art*
BC tour Middle East 1945-6 (6); Whitechapel 1959
(31); CC Prints, Tate, 1981 (ix)
REPR: *Horizon*, Feb 1944, between pp.116-7; CC
1946, p.25; *The Vision of the Fool*, 1947, col.pl.II;
British Art since 1900, 1962, col.pl.105; Anderson
col.pl.15
Tate Gallery

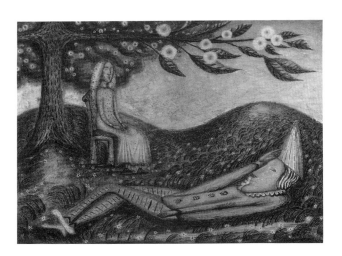

Purchased from the artist by the CAS in 1943. Painted at
Dartington. The Fool, in pantomime costume, sleeps on
a flower bedecked ground, and gains refreshment. A
young woman, his muse, also with her eyes closed, sits
on a chair in front of a tree, the branches of which have
glowing blossoms. This is the only representation of a
fool sleeping, although Collins executed a drawing in
1941 of a fool dreaming (repr. *The Vision of the Fool*,
1947, pl.16). Because both figures have their eyes closed
in reverie, the artist poses the question: who is dreaming
who? He referred to Lewis Carroll's *Through the
Looking Glass* for a comparative example. There Alice
encountered Tweedledum and Tweedledee under a tree.
While talking with them, she heard a sound 'like the

puffing of a large steam-engine in the wood near them.'
Tweedledee told her that this was the Red King snoring.
They all went to look at him. 'He had a tall red night-cap
on, with a tassel, and he was lying crumpled up into a
sort of untidy heap. "He's dreaming now" said Tweed-
ledee "and what do you think he's dreaming about?"
Alice said "Nobody can guess that." "Why, about you!"
Tweedledee exclaimed, clapping his hands triumph-
antly. "And if he left off dreaming about you, where do
you suppose you'd be?" "Where I am now, of course"
said Alice. "Not you!" Tweedledee retorted contemp-
tuously. "You'd be nowhere. Why, you're only a sort of
thing in his dream!". "If that King was to wake" added
Tweedledum, "you'd go out – bang! – just like a
candle!".'

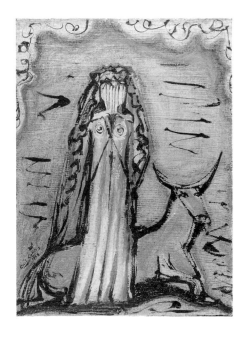

25 **The Bride** 1948
 Oil on canvas 10 × 7 (25.4 × 17.8)
 Inscribed: 'Cecil Collins/1948' b.l.
 EXH: Heffer Gallery, Cambridge 1950 (32);
 Leicester Galleries 1951 (38); Ashmolean Museum,
 Oxford, 1953 (8); Whitechapel 1959 (59)
 Private Collection

Painted in Cambridge. Although the bride is accom-
panied by a seated bull, she is not to be read as relating to
the myth of Europa. She is veiled and surrounded by a
curvaceous upper border, which the artist believes is
Eastern in feeling.

26 **The Artist's Wife Sewing** 1948
 Oil on board $16\frac{1}{4} \times 16\frac{5}{8}$ (41.3 × 42.2)
 Inscribed: 'Cecil Collins/1948' b.r. and with title,
 name and date of 'June/July 7th' on back
 EXH: Leicester Galleries 1951 (6); *Four
 Contemporaries*, Arts Council Gallery,
 Cambridge, 1952 (12)
 Private Collection

This board has been reused by the artist; a painting of a
geometricised head, dated 1938, is on the back. The
clothed table with flowers is like an altar and the whole
atmosphere in the room is sacramental. The curtained
window is a favourite memory from childhood, when
Collins would watch white clouds to gain a intuitive
sense of the numinous.

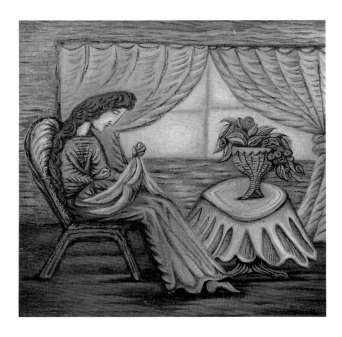

27 **Pastoral** 1949
Oil on canvas 20½ × 15 (52.1 × 38.2)
Inscribed: 'Cecil Collins 1949' b.l. and 'Feb 4
1949/Cambridge' on back
EXH: Heffer Gallery, Cambridge 1950 (33);
Leicester Galleries 1951 (19); Whitechapel 1959
(67)
REPR: *Victorian and Modern British Paintings
and Sculpture*, Sotheby's, 27 January 1986, Lot 281
Collection of Peter Bowles

This painting used to belong to the painter William
Johnstone. A naked female with long flowing hair sits
amid a hilly landscape with a single fir tree, and plays her
harp. The contour of the hills echoes her forms. She
looks eastward at the sun.

28 **Landscape: Sunrise** 1949
Oil on canvas 18 × 24 (45.8 × 61)
Inscribed: 'Cecil Collins/1949' t.r.
EXH: Leicester Galleries 1951 (21); Whitechapel
1959 (60)
REPR: *Studio*, January 1954, p.22; Anderson,
pl.46
Private Collection

This work used to belong to Sir John Rothenstein. It
represents an inner landscape, not one copied from the
exterior world. Anthony Bertram in his Studio article on
the artist, describes this work as showing a bolder vision
than previously. The invisible living forces of nature are
given the rhythmic feel of a dance by the use of lively
brushwork.

29 **Angels Dancing with the Sun and the Moon** 1949
Oil on paper 38 × 25½ (96.5 × 64.8)
Inscribed: 'Cecil Collins/1949' t.r.
EXH: Heffer Gallery, Cambridge 1950 (37);
Leicester Galleries 1951 (8); *The Mirror and the
Square*, Portsmouth, 1953 (46); *Yorkshire Artists'
Exhibition*, Leeds City Art Gallery, 1955 (167);
Whitechapel 1959 (73); Plymouth 1983 (4)
REPR: Anderson, pl.3
Private Collection

This work, like the previous entry, shows creation as a
dance. Many religions have the sacred dance as part of
their beliefs, even Christianity, although Christ's dance
with his disciples is somewhat hidden away in the
Apocryphal book of *The Acts of John*.

30 Elisabeth, the Artist's Wife 1950
Oil on canvas 17 × 14 (43 × 35.6)
Inscribed: 'Cecil Collins/1950' t.l. and with title,
name, date of '22 May/Cambridge' and 'Cecil
Collins made this/painting for his wife/in the
spring 1950' on back
EXH: Leicester Galleries 1956 (1); *A Paradise Lost*,
Barbican, 1987 (59)
REPR: Anderson, col.pl.43
Private Collection

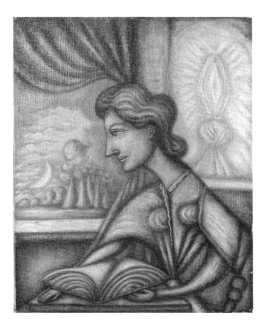

Elisabeth is reading a book, and has a lamp behind her.
A moonlit mountainous landscape is seen through the
curtained window. Collins used lead black as a pigment
in this work; this black is rarely used because it is
difficult to make and obtain. He got it from scientist
friends in Cambridge laboratories and it is part of his
experiments into the techniques of the Old Masters
which occupied him at this time.

31 Hymn to Night 1951
Oil on canvas 35½ × 47½ (90 × 120)
Inscribed: 'Cecil Collins/1951' b.r.
EXH: Leicester Galleries, 1951 (29); Whitechapel
1959 (77); Plymouth 1983 (5); Aldeburgh 1984 (no
number)
REPR: Anderson, col.pl.49
Private Collection

Christopher Middleton, who wrote the introduction to
the Whitechapel catalogue described this work as 'a
mature example of ... symbolic art, where willow
branches and foliage, the angel's wings and the swans
wings folding, all vary the blue imagery of repose. And
this repose is not a lethargy induced by material fatigue,
but is 'the tremendous dormant potency of a soul
unawakened'.

32 The Wanderers 1953
Gouache on board 19½ × 24¾ (49.5 × 62.9)
Inscribed: 'Cecil Collins 1953' b.r.
EXH: Heffer Gallery, Cambridge, 1950 (35 as
'Wandering Fools'); Leicester Galleries 1956 (10);
Yorkshire Artists' Exhibition, Leeds City Art
Gallery, 1957 (74)
REPR: *The Vision of the Fool*, 1981, pl.15 as 'The
Wandering Fools'
Leeds City Art Galleries

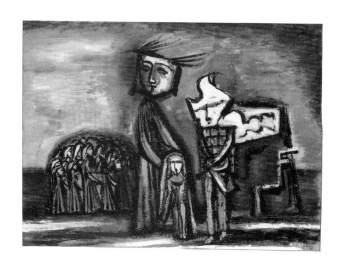

Unusually, pilgrims/fools/wanderers are gathered in
massed crowds, rather than being solitary figures.

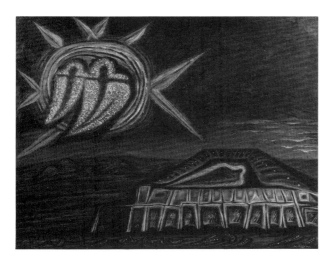

33 Hymn 1953
Oil on hardboard 48¼ × 60¼ (122.6 × 163)
Inscribed: 'Cecil Collins 1953' b.r.
EXH: *Figures in their Settings*, CAS, 1953 (11, as
'Hymn to Death'); Whitechapel 1959 (88); CC
Prints, Tate, 1981 (xiv)
REPR: *Tate Gallery Modern British catalogue*,
1964, vol.1, pl.23; Anderson, col.pl.61
Tate Gallery

The artist wrote to the Tate Gallery in 1961 that this
work 'was in my mind for a great many years before I
actually painted it and, like most of my works, it was a
concentration of the essence of an accumulated expe-
rience. It is a vision of Death as a moment of Transfigur-
ation.' Like 'The Promise' cat.no.10, it depicts souls
asleep in their earthly graves awaiting their moment of
transformation.

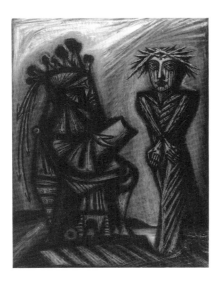

34 Christ Before the Judge 1954, reworked 1956
Oil on board 47½ × 35½ (120.7 × 90.2)
Inscribed: 'Cecil Collins/1954' b.l. and with title
and date of 'January 30 1954' on back
EXH: Leicester Galleries 1956 (15); *Yorkshire
Artists' Exhibition*, Leeds City Art Gallery,
Jan–Mar 1957 (119, where dated 1954); *The John
Moores Liverpool Exhibition*, Walker Art Gallery,
Nov 1957–Jan 1958 (62); *Sixteen Painters*, AIA
Gallery, 1959 (3); Whitechapel 1959 (89, where
dated 1954); Hamet Gallery 1972 (7)
REPR: *Art News and Review*, 18 February 1956,
p.4 (the earlier version); John Rothenstein, *British
Art Since 1900*, 1962, pl.104 (the reworked
version); Anderson, pls. 52 & 53 (both versions)
Private Collection

This work was awarded a prize of £100 in the Open
section of the John Moores exhibition. After the work
was exhibited in the Leicester Galleries in 1956, the artist
decided to rework the figure of Christ, changing him
from a gentle figure with a heart-shaped head into a
square-jawed resolute one. This work repeats the idea
presented in the drawing 'Fool Picking his Nose in
Front of a Bishop' (cat.no.91); here a carapaced Aztec
machine of a man confronts a vulnerable yet inviolate
'fool'.

35 The Gatherers of the Fruit 1955
Oil on board 48 × 36½ (122 × 93)
Inscribed: 'Cecil Collins/1955' b.r. and with title,
name, date of 'March 1955', and address on back
EXH: Leicester Galleries 1956 (11); Whitechapel
1959 (96, repr. pl.IX); *A Paradise Lost*, Barbican,
1987 (60)

REPR: Anderson, col.pl.51; *Resurgence*,
May–June 1988, no.128, colour cover and p.3
Private Collection

The tree is the Tree of Life and the woman who guards
the gathered fruit personifies fruitfulness and greenness.

36 **Figures in a Landscape** 1955
 Oil on board 27 × 27 (68.6 × 68.6)
 Inscribed: 'Cecil Collins/1955' b.r.
 EXH: Leicester Galleries 1956 (14); Plymouth
 1983 (6)
 REPR: *The Painter and Sculptor*, vol.1, no.1,
 Spring 1958, p.24
 Private Collection

A strange square-headed creature, part bird, but also
like a six-winged seraphim, visits a woman seated in a
landscape. The outstretched arms of the creature echo
the crucified arms of Christ. All is lit by the fiery rays of
the sun.

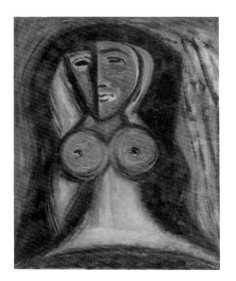

37 **Figure of a Woman** 1955
 Oil on paper 27 × 21¾ (69 × 54.5)
 Inscribed: 'Cecil Collins/1955' b.r.
 EXH: Leicester Galleries 1956 (12); Whitechapel
 1959 (99)
 REPR: Anderson, pl.111
 Private Collection

One of the most voluptuous depictions of the
woman/Anima in the artist's oeuvre.

38 **Landscape: Autumn** 1958
 Oil on board 36 × 48 (91.5 × 122)
 Inscribed: 'Cecil Collins 1958' b.r.
 EXH: Whitechapel 1959 (139); Hamet 1972 (11)
 REPR: Anderson, col.pl.60
 Private Collection

Although in outward natural terms the autumn is a time
for the dying down of plant life, Collins feels that the
yellow-gold harmonies of this painting do not signal
decay. Instead he believes that the yellow colour of an
autumn leaf is 'a colour signifying ecstasy, a sign is given
of renewal.' This is because yellow and gold indicate, in
alchemical terms, a transformation of something on to a
higher level.

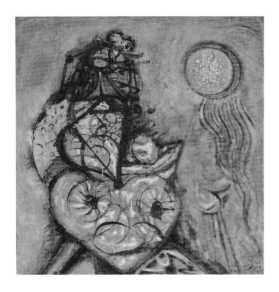

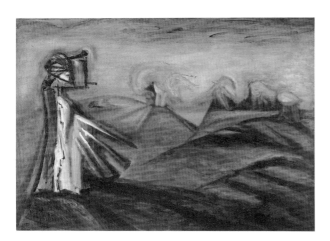

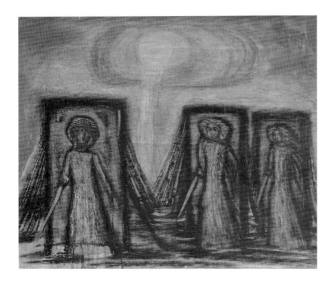

39 The Sibyl 1958
Oil on board $47\frac{5}{8} \times 44\frac{1}{4}$ (121 × 112.4)
Inscribed: 'Cecil Collins/1958' b.r. and with title
and date of 'August 1958' on back
EXH: Hamet 1972 (12)
Private Collection

The Sibyl with a heart-shaped body sits beside a
planetary body from which life forms flow. She is
masked and thus mysterious.

40 Hymn 1960
Oil on board $35\frac{3}{4} \times 47\frac{3}{4}$ (90.5 × 112)
Inscribed: 'Cecil Collins 1960' b.r.
EXH: Tooth Gallery 1965 (8 as 'Death', repr.
[p.8]); *The Hard-Won Image*, Tate, 1984 (35)
REPR: Anderson, pl.110
Bryce McKenzie-Smith

A masked figure to the left has flames instead of wings.
The eruptions of energy from the mountain tops in the
distance are in response to the power of the figure.
Although the colour is sombre it is a hymn to life.

41 Landscape of the Threshold 1962
Oil on board $42 \times 48\frac{1}{4}$ (107 × 123)
Inscribed: 'Cecil Collins 1962' b.r. and with title,
name, date of 'August 21 1962' and address on
back
EXH: Tooth Gallery 1965 (23, repr. [p.4]); Hamet
1972 (18)
REPR: Anderson, col.pl.68
Private Collection

Three angels with swords stand in front of doors,
barring the way to the distant Paradise over which the
sun pours out its light. The three angels each have a
different aspect, the one at the left is purification, in the
middle is justice and at the right is love.

42 The Guardian of Paradise 1963
Oil on board 41 × 46¾ (104 × 110)
Inscribed: 'Cecil Collins' b.l. and with title and
date of 'August 14 1963' on back
EXH: Tooth Gallery 1965 (12); Aldeburgh 1984
(no number)
REPR: Anderson, col.pl.64
Private Collection

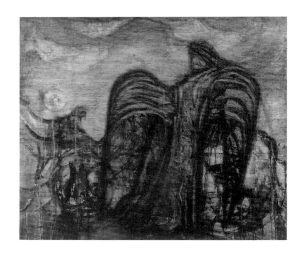

A huge purple angelic figure with her back to the viewer
dominates the landscape of Paradise seen in the distance.
She both warns and invites.

43 The Eternal Bride 1963
Oil on board 47¼ × 44⅞ (120 × 114)
Inscribed: 'Cecil Collins 1963' b.r. and with title
and date of 'September 1 1963' on back
EXH: Tooth Gallery 1965 (3, repr. on cover in
col.); Hamet 1972 (19); Plymouth 1983 (10); *The
Hard-Won Image*, Tate, 1984 (37)
REPR: Anderson, col.pl.62
Private Collection

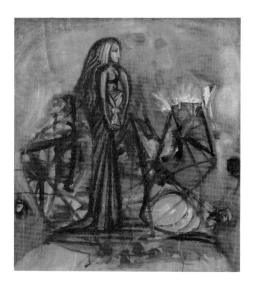

This work was turned the other way up after it was
begun, and then the central figure of the Anima or
Wisdom as the eternal bride emerged from the brush-
marks. She walks through the Universe carrying the
chalice, the cup of life, while before her, at her feet, is the
world egg.

44 Angel and Fiery Landscape 1964
Mixed media on board 13 × 12 (33 × 30.5)
Inscribed: 'Cecil Collins/1964' b.r.
EXH: Tooth Gallery 1965 (5, repr. [p.8]);
Plymouth 1983 (9, repr. on cover in col.);
Aldeburgh 1984 (no number)
REPR: Anderson, col.pl.65
Private Collection

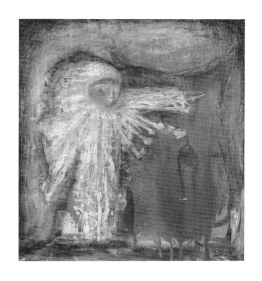

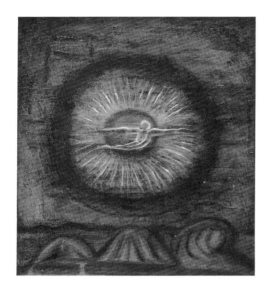

45 Angel of the Sun 1964
Mixed media on board 13 × 11¾ (33 × 29.9)
Inscribed: with title, medium, date of '12 January
1964' and address on back
Not previously exhibited
Private Collection

Above a range of violet mountains still to receive the
light, an angel flies before the concentric circles of the
sun.

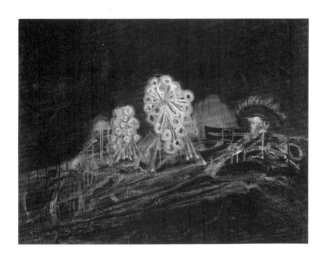

46 Landscape 1965
Mixed media on board 39½ × 47½ (97.5 × 120)
Inscribed: 'Collins 1965' b.l. and with title, name,
date of 'September 15 1965' and address on back
EXH: Tooth Gallery 1971 (21)
REPR: Anderson, col.pl.67
Private Collection

Collins regards this as the culmination of his matrical
works. The two cellular forms in the centre of the
composition pulsate with life and energy. Cellular forms
first appear in Cecil's paintings in 'Images in Praise of the
Love' of 1936 (cat.no.11).

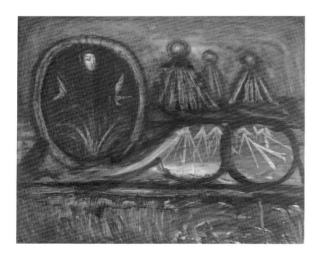

47 The Sacred Mirror 1966
Mixed media on board 30 × 35½ (75 × 90)
Inscribed: 'Cecil Collins/1966' b.r.
EXH: Tooth Gallery 1971 (6)
REPR: Anderson, col.pl.37
Private Collection

A mirror is used again in 'Tabula Rasa' 1987 (cat.
no.62). At the left a winged psyche and a playing
fountain are reflected in a mirror, revealing a sacred
world. The two smaller circular forms at the right are
like dials, which measure and indicate vibrations. A
stormy dawn sky is seen above three towers/mountains.

48 **Wounded Angel** 1967
Mixed media on board 30 × 36 (75 × 90)
Inscribed: 'Cecil Collins/1967' b.r.
EXH: Tooth Gallery 1971 (8, repr. [p.5]); Hamet
1972 (20); Plymouth 1983 (11, repr. [p.11]);
Aldeburgh 1984 (no number)
REPR: Anderson, col.pl.66
Private Collection

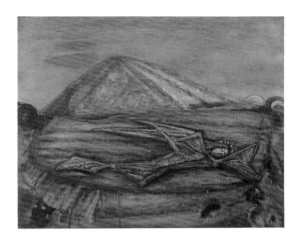

An angel wounded through its contact with the strife on
earth has returned to rest in Paradise. It lies prone on the
ground while the sun rises from behind the mountain.

49 **The Angel of the Flowing Light** 1968
Oil on board 48 × 42½ (122 × 106)
Inscribed: 'Cecil Collins 1968' b.r. and 'Angel of
the Flowing Light/1968/By Cecil
Collins/November 28th 1968/35 Selwyn
Gardens/Cambridge' on back
EXH: Tooth Gallery 1971 (20, repr. [p.2]); Hamet
1972 (21, repr. [p.15]); *The Hard-Won Image*,
Tate, 1984 (38, repr.)
LIT: *The Tate Gallery 1984–86: Illustrated
Catalogue of Acquisitions*, 1988, pp.128–30
REPR: *Tate Gallery Illustrated Biennial Report
1984–6*, 1986, p.84 in col; *Resurgence*, May–June
1987, p.15; Anderson, col.pl.114; *Tate Gallery
Illustrated Catalogue of Acquisitions 1984–86*,
1988, p.129
Tate Gallery

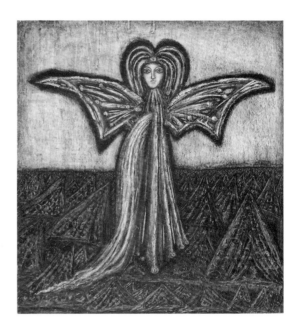

A simple monumental angel with butterfly wings floats
above mountain peaks not yet lit by dawn, and from its
heart flows a fountain of light. Its eyes convey sorrow,
love and judgement. Kathleen Raine believes that 'Such
a figure, too powerful for any secular art gallery, should
be in a shrine dedicated to St. Michael and All Angels . . .'
(CC, Painter of Paradise, p.23).

50 **Fool and Angel Entering a City** 1969
Mixed media on board 30 × 36 (75 × 90)
Inscribed: 'Cecil Collins 1969' b.l.
EXH: Tooth Gallery 1971 (3, repr. on cover in
col.)
REPR: *Illustrated London News*, September 1971,
p.63; Anderson, col.pl.113
Private Collection

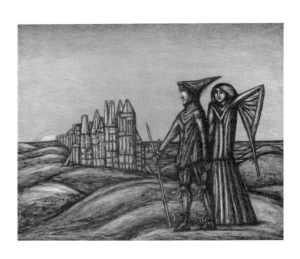

The fool in the guise of a pilgrim with his staff is
accompanied by a guardian angel. In the distant city is a
room in which the fool will be initiated and the risen sun
will shine directly into it. The guardian angel is also an
initiating angel. The sharp point of the fool's hat is
echoed by the angel's wing.

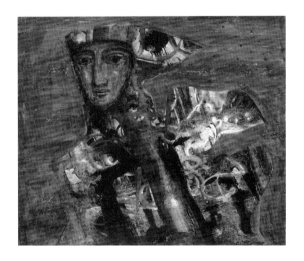

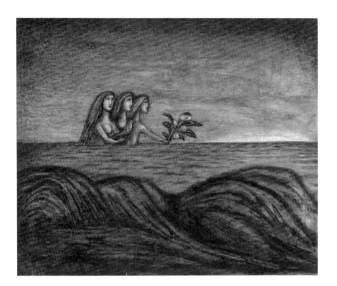

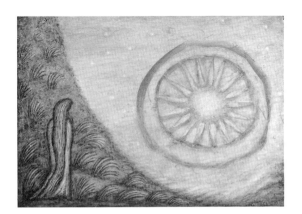

51 Angel of the Apocalypse 1969
Mixed media on board $11\frac{1}{2} \times 12$
Inscribed: 'Cecil Collins/1969' b.r. and with title,
name, date of 'May 24 1969' and address on back
EXH: Tooth Gallery 1971 (17, repr. [p.8]);
Plymouth 1983 (12); Aldeburgh 1984 (no number)
Private Collection

An apocalyse is a moment of revelation. This work is a
significant example of the way an image becomes
defined and revealed from Collins's gestural 'matrical'
brushwork.

52 Daybreak 1971
Mixed media on board $29\frac{1}{2} \times 33\frac{1}{2}$
Inscribed: 'Cecil Collins' b.r.
EXH: Tooth Gallery 1971 (1, repr. [p.8]);
Plymouth 1983 (13 as 'Dawn', repr. [p.10]);
Aldeburgh 1984 (no number)
REPR: *Resurgence*, May–June 1987, p.14;
Anderson, col.pl.72
Bryce McKenzie Smith

Three women summon the dawn; they turn their faces to
the east. One carries a bird and another a flowering
branch.

53 The Great Happiness 1974
Mixed media on board 6×8 (15.2×20.3)
Inscribed: 'Cecil Collins 1974' b.r. and with title,
name, date of 'July 20 1974' and address on back
EXH: d'Offay Gallery 1988 (2, repr. in col. on
cover)
Private Collection

A long-haired robed figure greets the sun. For a similar
event, see 'The Greeting' 1943, (cat.no.22).

54 **Head of a Fool** 1974
Mixed media on board 8 × 6 (20.3 × 15.2)
Inscribed: 'Cecil Collins/1974' b.r. and with title,
name and date of 'November 1974' on back
EXH: d'Offay Gallery 1988 (6)
REPR: Anderson, col.pl.63
Private Collection

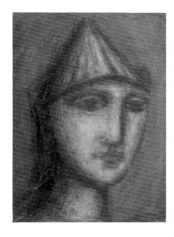

55 **The Artist's Wife Seated in a Tree** 1976
Tempera and pencil on board $23\frac{3}{4}$ × $19\frac{3}{4}$ (60 × 49)
Inscribed: 'For my very Dearest Bell/from your
ever loving Parc/The artist's wife seated in a
tree/1976/by/Cecil Collins/February 1976' and
address on back
EXH: Plymouth 1983 (14); Aldeburgh 1984 (no
number)
REPR: Anderson, col.pl.69
Private Collection

This composition first appeared in the form of a roneo
print of 1944, see CC Prints, Tate, 1984, catalogue no.12,
repr. p.17.

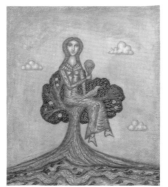

56 **Fool and Landscape** 1978
Mixed media on board 10 × 8 (25.4 × 20.3)
Inscribed: 'Cecil Collins 1978' b.l.
EXH: d'Offay Gallery 1988 (8, repr. in col.)
*Private Collection, courtesy of the Anthony
d'Offay Gallery, London*

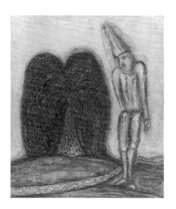

57 **Fool with a Butterfly** 1985
Mixed media on canvas 24 × 20 (61 × 50.8)
Inscribed: 'Cecil Collins 1985' b.r.
EXH: d'Offay Gallery 1988 (23, repr.)
REPR: Anderson, col.pl.90
Mr & Mrs Thomas E. Worrell, Jr

For butterflies in earlier works, see cat.nos.5, 8 and 109.
The butterfly symbolises rebirth and the fool symbolises
freshness and innocence. The work is about the em-
pathetic relationship between them.

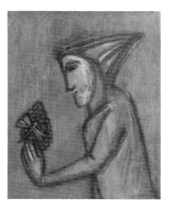

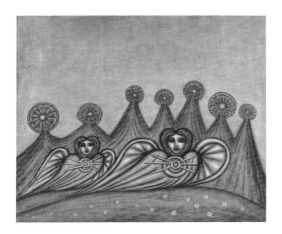

58 The Music of the Kingdom 1986
Tempera on canvas 19⅞ × 24 (50.5 × 61)
Inscribed: 'Cecil Collins 1986' b.r.
EXH: d'Offay Gallery 1988 (25, repr.)
REPR: Anderson, col.pl.74
Mr & Mrs Thomas E. Worrell, Jr

Two angels, companions of God, offer themselves as mediators for our particular happiness.

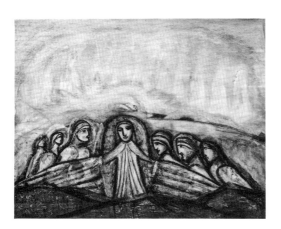

59 Walking on the Waters 1986
Mixed media on board 30 × 36 (76 × 92)
Inscribed: 'Cecil Collins 1986' b.r.
EXH: d'Offay Gallery 1988 (24)
REPR: Anderson, col.pl.112
*Private Collection, courtesy of the Anthony
d'Offay Gallery, London*

A central robed figure in a mandorla extends its arms. Reverential figures on either side attend.

60 Head of an Angel 1987
Tempera on board 24 × 20 (61 × 50.8)
Inscribed: 'Cecil Collins/1987' b.r.
EXH: d'Offay Gallery 1988 (29, repr.)
REPR: Anderson, col.pl.79
Collection of Peter Bowles

This powerful angel expresses innate harmony and wisdom. The artist says she is 'the icon of a cleansed mirror, which has been wiped free of dust to give a clear image'.

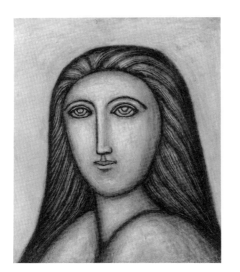

61 **The Dream of the Angel** 1987
 Tempera on canvas 28 × 32 (71.1 × 81.3)
 Inscribed: 'Cecil Collins 1988' b.r.
 EXH: d'Offay Gallery 1988 (26)
 Private Collection

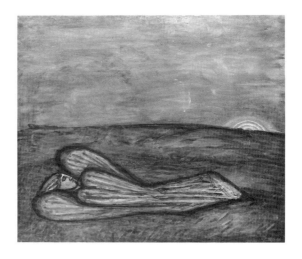

An angel lies on the bare ground and dreams, enfolded in its wings. It is the spiritual counterpart to 'The Sleeping Fool' (cat.no.24).

62 **Tabula Rasa** 1987
 Tempera on canvas 24 × 20 (61 × 50.8)
 Inscribed: 'Cecil Collins/1987' b.r.
 EXH: d'Offay Gallery 1988 (28, repr.)
 Mr & Mrs Thomas E. Worrell, Jr

This is part of an ongoing cycle of works called Rooms of Childhood (for another see cat.no.104). The chosen title implies the wiping out of all debts, by which purification can happen. The long haired figure has attained a state of grace and can then see in the mirror the true nature of the soul.

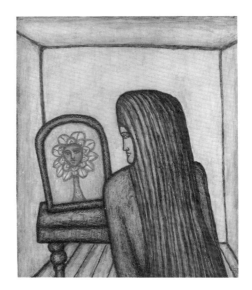

63 **Nocturne** 1987
 Oil on board 28 × 32 (71.1 × 81.3)
 Inscribed: 'Cecil Collins/1987' b.r.
 EXH: d'Offay Gallery 1988 (30)
 REPR: Anderson, col.pl.80
 Private Collection

This work symbolises the mystery of night as a secretive feminine spirit. The word nocturne not only refers to the night but is also the generic title for a lyrical piano piece. The ripples which emanate from the figure are like eddies of sound. A stone dropped into the still waters of a lake produces the same effect and the artist is interested in the resonances of both sound and water.

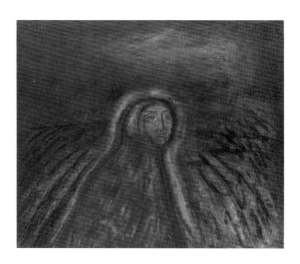

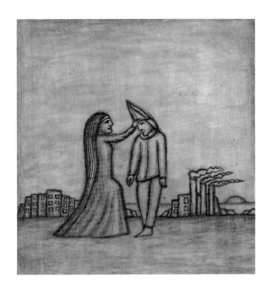

64 Woman and Fool 1988
Tempera on canvas 18 × 16 (45.7 × 40.6)
Inscribed: 'Cecil Collins/1988' b.r.
EXH: d'Offay Gallery 1988 (31)
Anthony d'Offay Gallery, London

A woman crowns a fool in front of a grim urban scene. The city only appeared in a handful of works by Collins in the early 1940s (see cat.nos.18 and 19), but he now feels that it is likely to return into his paintings. When it appeared in the 1940s it was as an intuitive response to the wartime destruction of Plymouth, his birthplace. Its return is in response to the crisis of modern city life. The crowning of the fool in front of the city sanctifies the place, and bestows blessings. A further element of hope comes in the form of the rising sun at the extreme right.

65 The Music of Dawn 1988
Tempera on canvas 28 × 33 (71.1 × 83.8)
Inscribed: 'Cecil Collins 1988' b.r.
EXH: d'Offay Gallery 1988 (32, repr.)
Anthony d'Offay Gallery, London

A great golden priestess with a pilgrim's staff stands on the seashore and the golden light of the rising sun suffuses the scene.

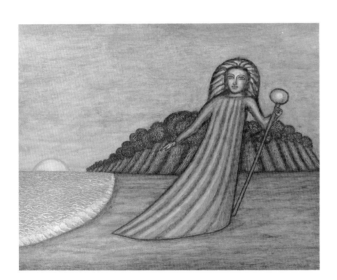

66 **Study of a Hand** 1930
Red chalk on white paper 10 × 7 (25.4 × 17.8)
Not inscribed
EXH: Whitechapel 1959 (146)
Private Collection

Executed while Collins was a student at the RCA. The artist believes that this is an imaginative drawing, not done from life. The hand emerges from a sleeve, and could be read as being raised as if in the act of blessing.

67 **Portrait of Elisabeth, the Artist's Wife** 1932
Pencil on white paper $11\frac{3}{4} \times 8\frac{7}{8}$ (30 × 22.5)
Inscribed: 'Collins 1932' b.l.
EXH: ? Whitechapel 1959 (150 – 'Head of a Woman')
REPR: Anderson, pl.12
Private Collection

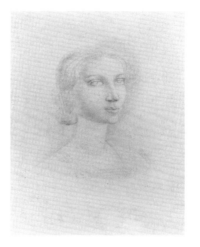

Cecil married Elisabeth Ramsden, a fellow student at the RCA, on 3 April 1931. From that date on she became his muse, and her face, idealised as here, is used for his female figures.

68 **The Sitting Room at Monk's Cottage** 1932
Ink and watercolour on white paper $29\frac{1}{4} \times 22$ (75 × 55)
Not inscribed
Not previously exhibited
REPR: Anderson, col.pl.14
Private Collection

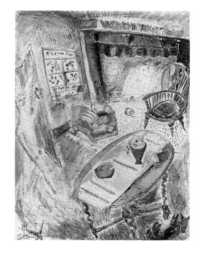

This depicts the front ground floor room of Monk's Cottage and is a literal record of its character and furnishings, except for the winged angel with a flower who enters by the front door. As if to complement the visiting angel, the scene on the cast iron fireback within the large fireplace recess shows two figures ascending while a third one, earthbound, watches. A contemporary oil painting shows the exterior of Monk's Cottage, with Cecil and Elisabeth's heads at two of the windows and two angels hovering over the roof of the house. The ink marks were made with the end of a wooden matchstick.

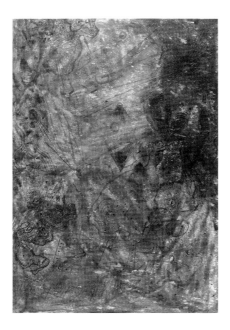

69 **The Music of the Worlds** 1933
Red and black ink and watercolour on white paper
$21\frac{3}{4} \times 14\frac{3}{4}$ (52.7 × 37.5)
Inscribed: 'Cecil Collins 1933' b.r. and 'Night of
Nights/Fantasia in C Sharp/King of France/James
the First/James Henry Cecil Collins/the infinite as
no eye/with which it can see finite' on back
EXH: ? Barn Studio, Dartington, 1937 as one of
the unframed, unlisted works;? Whitechapel 1959
(152 – 'Dance' 1933)
REPR: Anderson, col.pl.95 (detail)
Private Collection

Red and black ink lines trace rays of light pouring forth
from both biomorphic shapes and sun-like planets. A
dark watercolour wash indicates the infinite swirls of
outer space.

70 **The Pilgrim** 1935
Ink and watercolour on cream paper $8\frac{3}{4} \times 6\frac{1}{2}$
(22.3 × 16.5)
Inscribed: 'Cecil Collins 1935' t.l.
Not previously exhibited
REPR: *Malahat Review*, Jan 1970, p.65
Private Collection

A confident and muscular nude male figure holds a
flowery bough which ends in a flail. The staff held in his
other hand denotes his status as a pilgrim. A bony spine
to his right bursts into life. Bones with rays issuing from
them are found on his head and behind him, in the
landscape.

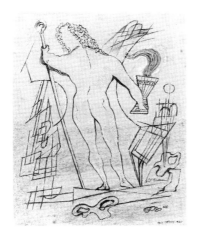

71 **The Pilgrim** 1935
Black and white ink and chalk on cream paper
$9\frac{5}{8} \times 7\frac{5}{8}$ (24.6 × 19.4)
Inscribed: 'Cecil Collins 1935' b.r.
EXH: ? Barn Studio, Dartington 1937 (34 – 'The
Image of the Pilgrim'); Whitechapel 1959 (156)
REPR: CC 1946, p.31; *Malahat Review*, Jan 1970,
p.66
Private Collection

This pilgrim turns his back on the viewer and is
equipped not only with a staff but also with a chalice
flowing with light. Two bone forms lie on the ground
while linear scaffolding surrounds the figure. White ink
is introduced in this drawing; small cross-hatched
strokes of it create volume inside the contours of the
male figure while decorative short lines attach them-
selves to the black lines of the scaffolding. This geo-
metrical scaffolding is usually confined to Collins's
graphic work (see cat.nos.73,74,75). However an asser-
tive geometrical structure joins with the figure in the
canvas of 'The Poet' (cat.no.18).

72 **Pilgrim Resting** 1935
White ink on green paper $9\frac{3}{4} \times 7\frac{3}{8}$ (24.8 × 18.7)
Inscribed: 'Cecil Collins 1935' t.l.
EXH: ? Bloomsbury Gallery 1935 (19)
REPR: Anderson, pl.25
Private Collection

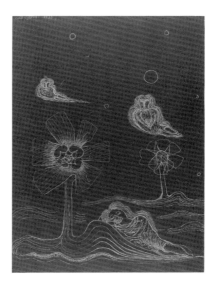

This is probably the first drawing executed entirely using white ink, and the artist realised his forms in white in order to impart to them a special quality of energy. The swaddled figure takes a temporary rest on his quest. The flower under which the pilgrim rests is much larger than himself because he has no fixed size. Two angels hover over him in a starry sky, the larger of which holds a chalice.

73 **Adam Blessing the Kingdom** 1935
White ink and pencil on beige paper $15\frac{1}{4} \times 10\frac{1}{2}$
(38.7 × 26.7)
Inscribed: 'Cecil Collins 1935' t.l.
Not previously exhibited
Private Collection

Adam, with a round-headed staff in his right hand, raises his left hand in blessing. No life forms have yet come into being for him to bless; instead he is surrounded by bone forms, a bony spine and linear scaffolding. Bone forms and planets are seen in the sky. In medieval art the scene of Adam naming the beasts was sometimes included in narrative cycles illustrating the book of Genesis, but this subject could well be iconographically unique.

74 **A Song, The Worlds Rejoice** 1935
White ink on green paper $17\frac{1}{2} \times 14\frac{7}{8}$ (44.4 × 37.8)
Inscribed: 'Cecil Collins/1935' b.r.
EXH: Whitechapel 1959 (157)
Private Collection

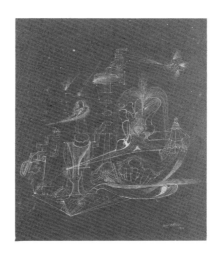

At the lower left of this composition a rooted tree form is transformed firstly into a chalice form and then, as it progresses upwards on the paper, into an angelic form. The composition is filled with an architectural scaffolding which surrounds a fountain of light.

75 Portrait of Elisabeth 1935
White ink on brown paper 13 × 10½ (33 × 26.7)
Inscribed: 'Cecil Collins/1935' t.r.
EXH: *Temenos Exhibition*, Dartington 1986 (no
number)
Dartington Hall Trust

A sensitive portrait of the head and shoulders of
Elisabeth, the artist's wife. Unusually she is shown with
a naked breast. Geometrical scaffolding and bone forms
encompass her.

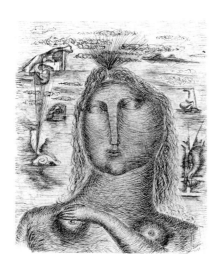

76 Image of a Woman 1935
Black ink and blue chalk on white paper $9\frac{3}{4} \times 7\frac{3}{4}$
(24.8 × 19.7)
Inscribed: 'Cecil Collins/1935' b.r.
EXH: ? Bloomsbury Gallery 1935 (6, 'Head') or (2,
'Figure with Forms') or (13, 'Image with rays')
Private Collection

The present title is a recent one, because the original is
not known. This imposing formal but anonymous head
serves as a counterpart to the contemporaneous drawing
of Elisabeth (cat.no.75). The woman's long flowing hair
is centrally parted and the top of her head rides just
above the horizon line drawn in the distance. From
either the horizon or the top of the woman's head rays
issue forth. The clever placing of these lines mean that
they can be read as either the rays of the sun as it rises
above the horizon into a cloudy sky, or as an indication
of the inner psychical energy of the figure.

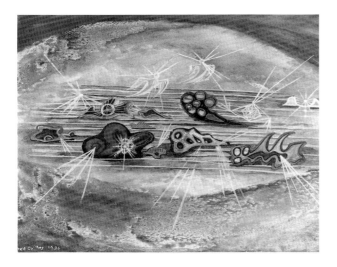

77 Mysterious Rejoicing 1936
Gouache on paper $8\frac{5}{8} \times 10\frac{3}{4}$ (21.9 × 27.4)
Inscribed: 'Cecil Collins 1936' b.l. and
'Mysterious Rejoicing 1936' on back
Not previously exhibited
Private Collection

Bone and chrysalis forms lie on the ground and rays issue
forth from some of them. Two white angelic forms with
rays rise up from the forms on the ground. The rejoicing
in the title refers to the capacity of the angelic forms to
transform the dead symbols of bone and chrysalis case
into ones of new life.

78 **Seashell-Mysterious Joy** 1936
Gouache on paper $10\frac{3}{4} \times 15\frac{3}{4}$ (27.4 × 40)
Inscribed: 'Cecil Collins/1936' b.r.
EXH: ? Barn Studio, Dartington, 1937 (24 – 'Image
of the Seed')
Private Collection

A planetary firework display takes place over an expanse
of water, and all is contained within a brown seed or
shell-like form. Collins loved sea-shells from an early
age and would put them to his ear to hear the sound of
the sea in them.

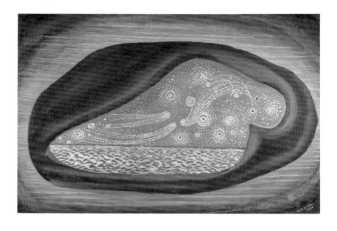

79 **Head** 1936
Ink, glue and watercolour on white paper $12\frac{1}{2} \times 9\frac{3}{8}$
(31.7 × 23.8)
Inscribed: 'Cecil Collins 1936' t.l.
EXH: ? Whitechapel 1959 (158 'Head', with
dimensions reversed)
Private Collection

Collins employed a resinous substance in some drawings
of the 1930s, and it is used in this work, dispersed over
the surface in order to lend a sense of mystery to the
head.

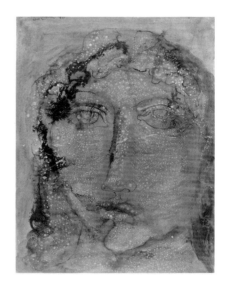

80 **The Robes of Life** 1936
Ink and watercolour on cream paper $15 \times 10\frac{3}{4}$
(38.2 × 27.3)
Inscribed: 'Cecil Collins 1936' b.r.
EXH: *A Paradise Lost*, Barbican, 1987 (43)
Private Collection

Collins uses the world of seeds, plants and flowers as an
analogy of the life of the soul. Those forms are employed
here to show how they are transformed by growth, as
they thrust themselves up towards the sun. The plant
and geological world is depicted here cut in half to reveal
this growth.

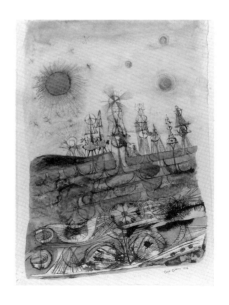

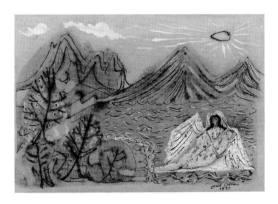

81 Scene in Paradise 1937
Gouache and black ink on beige paper $8\frac{1}{4} \times 11$
(21×28)
Inscribed: 'Cecil Collins/1937' b.r.
EXH: Lefevre 1945 (13)
Private Collection

A white robed angel rests and enjoys itself in Paradise, floating like an island on the surface of a lake.

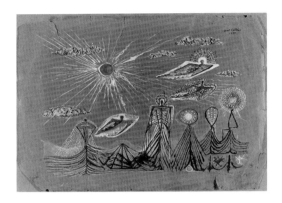

82 Grove of Angels 1937
Ink and gouache on brown paper $9 \times 12\frac{1}{4}$
(22.8×31.1)
Inscribed: 'Cecil Collins/1937' t.r.
Not previously exhibited
Private Collection

The geometrical forms growing up from the earth's surface are similar to the plant forms in 'The Robes of Life' (cat.no.80), and these too are cut in half to show their structure. As a group of angels pass over the land, one of the forms responds to them and begins to be transformed into an angel.

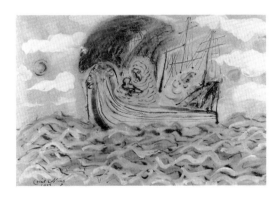

83 The Voyage 1937
Gouache and ink on grey paper 8×10 (20.3×25.4)
Inscribed: 'Cecil Collins/1937' b.l.
EXH: Plymouth, 1983 (15); Aldeburgh, 1984, (no number)
Private Collection

A mother and child group, a subject rare in Collins's work, sit in the helm of a dark-sailed ship. A drawing of 1933, now lost, was entitled 'The Voyage of Ulysses' and this could also have depicted a sea-journey. A voyage offers the opportunity for discovery in both inner and outer worlds.

84 The Dance of the Worlds 1939
Gouache on card $24\frac{1}{2} \times 30\frac{1}{2}$ (62.2×77.5)
Inscribed: 'Cecil Collins/1939' t.r. and 'Cecil Collins/December 1939' on back
EXH: ? Cartwright Hall, Bradford 1950 (664)
Private Collection

Paper labels written in the artist's hand on the back of this work give an alternative title of 'Sacred Dance'. This work marks the first appearance of a cubist/vorticist angular and faceted style in Collins's graphic work, which he used to denote the masculine character. The three faceted figures rendered in this style dance above a form which is parted by a flow of water or light.

85 **The Meeting of the Fools** 1939
Gouache and pencil on white paper $7\frac{5}{16} \times 10\frac{7}{16}$
(18.5×26.5)
Inscribed: 'Cecil Collins 1939' b.l.
EXH: Lefevre 1945 (15)
REPR: *The Vision of the Fool*, 1947, pl.19;
Anderson, pl.28
Private Collection

This is believed to be the first drawing of fools. The two outer figures have long hair, calf-length robes and jaunty hats while the central figure has a long robe with a red apron shape, a staff and a bishop-like mitre. They meet at the edge of the sea.

86 **Procession of Fools** 1940
Ink on white paper $14\frac{5}{16} \times 19\frac{5}{16}$ (36.4×49)
Inscribed: 'Cecil Collins/1940' b.r.
EXH: Lefevre 1944 (40); Whitechapel 1959 (164);
Plymouth, 1983 (257; Aldeburgh, 1984 (no number)
REPR: CC 1946, p.34; *The Vision of the Fool*,
1947 pl.26; Anderson, pl.85
Dartington Hall Trust

This work was one of several blown off the walls of the Lefevre Gallery on the night of 23 February 1944 when the St James's area of London was badly bombed. Others in the gallery then were cat.nos.87,91,92,93,94, 95,96,97,98,100,104.

87 **Hymn** 1940
Gouache on brown paper 14×18 (35.7×45.7)
Inscribed: 'Cecil Collins/1940' t.r.
EXH: Lefevre 1944 (17);? Heffer Gallery,
Cambridge 1950 (22)
REPR: CC 1946, p.39
Private Collection

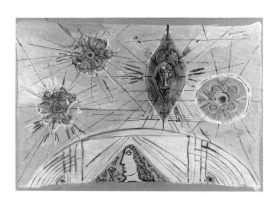

A paper label on the back in the artist's hand gives the alternative title of 'The Joy of the Worlds'. A contemplative head seen in profile is contained within an arched shape below, along with vestigial bone and shell forms and a small chalice. Flower-like worlds or stars give off their rays above. The large mandorla shape above also contains a chalice – 'As above, so below'.

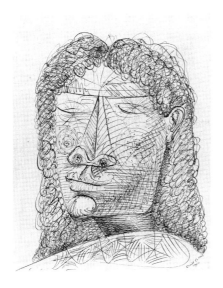

88 Head 1940

Ink on cream paper $19\frac{3}{4} \times 15$ (50.2 × 38.1)
Inscribed: 'Cecil Collins/1940, b.r.
EXH: ? Whitechapel 1959 (162, 'Head' with
dimensions reversed)
REPR: CC 1946, p.30, where dated 1935 in
caption
Private Collection

In Collins's work a head with closed eyes denotes a
figure in a state of inner contemplation.

89 The Oracle 1940

Ink on white paper, with collaged addition
$14\frac{1}{2} \times 21\frac{1}{2}$ (36.5 × 55)
Inscribed: 'Cecil Collins 1940' b.r. and 'The
Oracle' and 'May 1940' on back
EXH: Scottish National Gallery of Modern Art,
Edinburgh 1969(21); Hamet Gallery 1972 (22, repr.
[p.10]); CC Prints, Tate, 1981 (iv); *A Paradise Lost*,
Barbican, 1987 (49, repr. pl.121)
REPR: Anderson, pl.118
Private Collection

A creative force emanates from this powerful enthroned
figure which is both male and female. Its face is partly
veiled by a visor which indicates its oracular power and
links it to the visored knights who sought the grail. The
energetic rays which issue from a device held by its
muscular arm cause a waterfall to cascade, and from
behind the mountains the sun rises.

90 Landscape with Heads 1940

Ink and watercolour on white paper $15\frac{1}{4} \times 22$
(38.5 × 55.5)
Inscribed: 'Cecil Collins 1940' b.r. and 'Cecil
Collins/June 1940/TOTNES Devon' and 'Hymn'
on back
EXH: CC Prints, Tate, 1981 (v)
LIT: *The Tate Gallery 1974–76: Illustrated
Catalogue of Acquisitions*, 1978, pp.82–4
REPR: *The Tate Gallery 1974–76 Illustrated
Catalogue of Acquisitions*, p.82; Anderson, pl.102
Tate Gallery

When catalogued by the Tate in 1977, the artist changed
the title of this work from 'Hymn' to 'Landscape with
Heads'. These two heads are flowerings of the land-
scape. The profile head to the right with its rays of
energy is similar to that found in 'The Oracle'
(cat.no.89).

91 **Fool Picking his Nose in front of a Bishop** 1940
Ink, gouache and watercolour on white paper
$14\frac{1}{2} \times 10\frac{1}{2}$ (37 × 26.8)
Inscribed: 'Cecil Collins 1940' b.r.
EXH: Lefevre 1944 (35); Whitechapel 1959 (165);
Plymouth 1983 (16); Aldeburgh, 1984 (no number)
REPR: *The Vision of the Fool*, 1947, pl.23;
Anderson, pl.32
Dartington Hall Trust

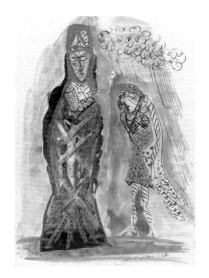

Collins contrasts the figure of the Bishop, enclosed in his heavy carapace of doctrine, with the irreverent and free figure of the fool, whose long robe loose at his back echoes the shapes of angels' wings.

92 **Man in Meditation** 1942
Ink and watercolour on white paper 22 × 15
(55.9 × 38.1)
Inscribed: 'Cecil Collins/1942' t.r.
EXH: Lefevre 1944 (24): *Modern British Paintings*,
Lefevre Gallery, 1948 (11); Whitechapel 1959
(182); Plymouth 1983 (18); Aldeburgh, 1984 (no
number)
REPR: CC 1946, frontispiece in col.
Sir Michael Culme-Seymour

In 1944 this work belonged to Mrs Duncan Macdonald, wife of one of the directors of the Lefevre Gallery. The contemplative mood of this male head seen in profile with closed eyes is close to that found in the painting 'The Voice' (cat.no.13).

93 **The Peace of the Fool** 1942
Pencil on white paper $21\frac{1}{2} \times 14\frac{1}{2}$ (54.6 × 36.8)
Inscribed: 'Cecil Collins 1942' b.l.
EXH: Lefevre 1944 (41); Whitechapel 1959 (180);
CC Prints, Tate, 1981 (vi)
REPR: *The Vision of the Fool*, 1947, pl.3; *The
Vision of the Fool*, 1981, pl.2
Peter Nahum, London

This work belonged to Mr and Mrs Brailsford, friends that Collins made at Dartington. It shows the female Anima giving a brimming chalice to a fool, who is humble enough to receive it.

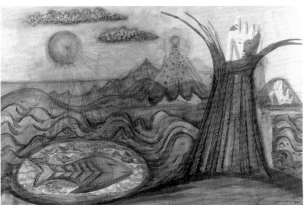

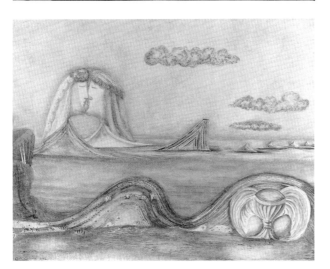

94 **Head of a Woman** 1942
Ink and gouache on white paper $14\frac{1}{2} \times 21\frac{1}{2}$
(36.9×54.5)
Inscribed: 'Cecil Collins 1942' b.r.
EXH: Lefevre 1944 (30); 4 *Contemporaries*,
Cambridge, 1952 (20); Ashmolean Museum,
Oxford 1953 (2); Whitechapel 1959 (176)
REPR: CC 1946, p.5
David Orr

95 **The Bride** 1942
Ink and watercolour on white paper $15\frac{1}{2} \times 22$
(39.3×55.9)
Inscribed: 'Cecil Collins 1942' b.r.
EXH: Lefevre 1944 (25); Whitechapel 1959 (184,
repr. pl. VIII); Plymouth 1983 (17); Aldeburgh,
1984) (no number); *Temenos Exhibition*,
Dartington Hall, 1986 (no number)
REPR: CC 1946, p.37
Dartington Hall Trust

Collins's painting of 'The Bride' (cat.no.25) depicts her
veiled and mysterious, and a sense of mystery pervades
this landscape also.

96 **Landscape: The Mountains** 1942
Ink and watercolour on white paper $14\frac{9}{16} \times 17\frac{5}{16}$
(37×44)
Inscribed: 'Cecil Collins 1942' and 'Landscape,
The Mountains 1942/by Cecil Collins/Dartington
Hall/Totnes/Devon/(November)' on back
EXH: Lefevre 1944 (22)
REPR: Anderson, pl.104
Private Collection

In the distance two mountain peaks end in contempla-
tive heads which prepare to kiss. In the foreground the
wings of a chalice enclose two egg-like forms.

97 The Sibyl [The Blessing] 1942
Pencil on white paper $21\frac{1}{2} \times 14\frac{1}{2}$ (54.6 × 36.8)
Inscribed: 'Cecil Collins 1942' b.l.
EXH: Lefevre 1944 (37 as 'The Blessing');
Whitechapel 1959 (170); Hamet 1972 (23, repr.
[p.11])
REPR: CC 1946, p.6 as 'The Blessing'; Anderson,
pl.119 as 'The Sibyl'
Private Collection

The movement of the Sibyl's dance causes the curtain to
blow aside and reveal the treasures of childhood, shells
and a lit chalice. She dances with a thorny branch and
wears horns on her head. The horns are an attribute of
power, for in mythology a Sibyl was a priestess endowed
with the gift of prophecy.

98 Landscape with Birds 1942
Watercolour on white paper $15 \times 21\frac{1}{2}$ (38.1 × 54.6)
Inscribed: 'Cecil Collins 1942'
EXH: Lefevre 1944 (26); Whitechapel 1959 (172)
Collection of Peter Bowles

This red-hued spiky landscape is devoid of human
figures, and is the haunt of fantastic birds.

99 The Artist's Wife Lighting a Lamp 1942
Pencil on white paper $21\frac{3}{8} \times 14\frac{3}{4}$ (54.3 × 37.5)
Inscribed: 'Parc Autumn 1942' b.r.
EXH: CC Prints, Tate, 1981 (vii)
Private Collection

Elisabeth sits before an open book in which the word
'Love' is inscribed. A swan keeps her company. ('Parc' is
Elisabeth's pet name for Cecil Collins; it is short for
parcel because he would sometimes have his clothing
tied up with bits of string.)

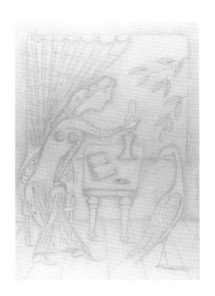

100 Two Fools Dancing 1942
 Ink and pencil on white paper $19\frac{1}{2} \times 14\frac{1}{4}$
 (49.5 × 36.2)
 Inscribed: 'Cecil Collins 1942' b.l.
 EXH: Lefevre 1944 (46 as 'Fools Dancing', repr. on
 cover); Whitechapel 1959 (171); *British Drawings*
 1939–49, Scottish National Gallery of Modern Art,
 Edinburgh, 1969 (no number)
 REPR: CC 1946, p.27 as 'Dance of the Fools'; *The*
 Vision of the Fool, 1947, pl.30 as 'Fools Dancing';
 The Vision of the Fool, 1981, pl.13 as 'Fools
 Dancing'; Anderson, pl.86 as 'Two Fools Dancing'
 Private Collection

A preliminary pencil drawing of arcs and sweeps underlays the animated calligraphic ink lines which make up these two figures. The undulating contours of the fool on the right are similar to those which described the body of the fool on the left in cat.no.86. The small conical hat with wavy plume worn by this figure on the right echoes the tower top with fluttering banner seen in the distance.

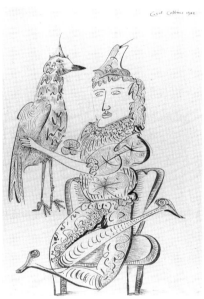

101 Fool with a Bird 1942
 Ink on white paper $15 \times 9\frac{3}{4}$ (38.1 × 24.7)
 Inscribed: 'Cecil Collins 1942' t.r.
 EXH: Lefevre 1944 (36); Whitechapel 1959 (177,
 repr. Pl.11)
 REPR: *The Vision of the Fool*, 1947, pl.27; *The*
 Vision of the Fool, 1981, pl.11; *Resurgence*,
 May–June 1987, p.12
 Private Collection

The artist always says of this work that 'a bird in the hand is worth two in the bush'!

102 The Blessing 1942
 Ink on white paper $12 \times 9\frac{3}{4}$ (30.5 × 24.8)
 Inscribed: 'Cecil Collins 1942' b.r.
 Not previously exhibited
 REPR: Anderson, pl.103
 Private Collection

An imperative forearm emerges from a triangle of drapery, and dominates a winding river in a landscape. This and the following drawing (cat.no.103) share affinities with the symbolic images that were used in 16th and 17th century emblem books.

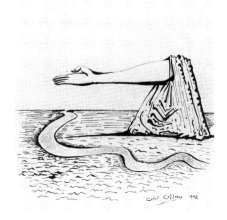

103 Landscape: The Immortal Life 1942

Ink on white paper 10 × 14½ (25.4 × 36.8)
Inscribed: 'Cecil Collins 1942' b.r.
EXH: Whitechapel 1959 (175); *A Paradise Lost*,
Barbican, 1987 (50, as 'Landscape', repr. pl.9)
Private Collection

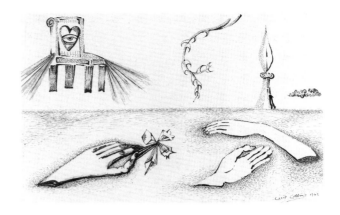

This marks the first appearance in Collins's work of the device of the eye in the heart, which appears as the central motif of the chair which rises above the earth and distributes rays. The device of the eye in the heart is used again in Collins's west window design for the church of St Michael and All Saints, Basingstoke, unveiled in 1988. An Arts Council film about the artist, made in 1978, was titled 'The Eye of the Heart'. The artist believes the idea of the eye of the heart to be of Sufi origin.

104 Thou Lovest/Figure in a Room 1942

Ink on white paper 14¾ × 9¾ (37.4 × 24.8)
Inscribed: 'Cecil Collins 1942' b.r. and 'Thou
Lovest/new title/Figure in a Room' on wooden
backboard
EXH: Lefevre, 1944 (48)
REPR: CC 1946, p.20
Private Collection

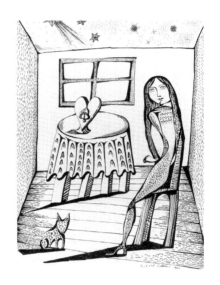

As a child Collins imagined that at night the ceiling of his bedroom disappeared to be replaced by a starry sky as here. This drawing is one of a proposed cycle of works entitled 'The Rooms of Childhood' which the artist considers to be worthy of further development. A painting in the cycle is 'Tabula Rasa' 1987 (cat.no.62).

105 Fool and Flower 1944

Ink on white paper 11 × 7½ (28 × 19.1)
Inscribed: 'Cecil Collins 1944' b.l.
Not previously exhibited
Private Collection

This drawing served as the basis for a roneo print made in 1944 in an edition of 12. The print is in the collection of the Tate Gallery.

106 The Invocation 1944
Ink and watercolour on white paper 15 × 22 1/16
(38 × 56)
Inscribed: 'Cecil Collins 1944' t.r.
EXH: Lefevre 1945 (56 as 'Figure and Landscape –
The Invocation'); Whitechapel 1959 (195, repr.
pl.IV)
REPR: CC 1946, p.48; Studio, Jan 1954, p.21;
Malahat Review, Jan 1970, p.71; Anderson, col.
pl.42
Private Collection

Drawn at Hollins, Luddenden in Yorkshire, the home of
his wife's parents. The title implies that the female figure
is in the act of summoning something by her powers, and
it may well be the beautiful landscape which surrounds
her. A drawing by Leonardo, 'Pointing Lady in a
Landscape' *c*.1515, of a beautiful long-haired woman in
a landscape gesturing to the viewer shares a similar
mood with this work.

107 The Field of Corn 1944
Ink and watercolour on white paper 14 × 22 1/16
(35.5 × 56)
Inscribed: 'Cecil Collins/1944' b.l.
EXH: Lefevre 1945 (39); *The East Anglian Scene*,
Arts Council Gallery, Cambridge, 1949 (7);
Whitechapel 1959 (195, repr, pl.III)
REPR: Anderson, pl.109
*Board of Trustees of the Victoria and Albert
Museum, London*

As the life-giving sun passes over the landscape, the
stooks of corn rise up in greeting, as do the waving trees
and undulating hills.

108 Still Life, The Coming of Day 1944
Ink and watercolour on white paper 23 1/4 × 15
(59 × 38)
Inscribed: 'Cecil Collins/1944' t.r.
EXH: Lefevre 1945 (51); *CAS gifts to Yorkshire
1920–80*, Sotheby's, Harrogate, 1980 (7)
*Kirklees Metropolitan Council, Huddersfield Art
Gallery*

Given to Kirklees by the Contemporary Art Society in
1965. A female head with flowing hair rests on a table
along with a chalice and vase of flowers. Her hair
conjoins with the flower-heads. The table is placed amid
the sea, above which the sun rises.

109 The Gardener 1944
Ink and watercolour on white paper $14\frac{1}{4} \times 21\frac{3}{4}$
(37.5×55.5)
Inscribed: 'Cecil Collins 1944' t.r.
EXH: Lefevre 1945 (40); Whitechapel 1959 (194)
REPR: *Malahat Review*, Jan 1970, p.70;
Anderson, pl.36
Derby Art Gallery

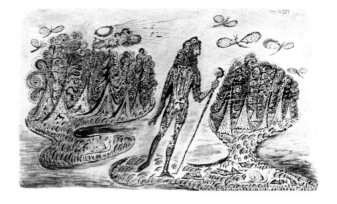

Given to Derby by the Contemporary Art Society in 1946. Executed at Hollins, Luddenden (like cat.no.106). The gardener is at home in his setting since his body is filled with the same decorative forms as the foliage of the trees. Butterflies dance above the tree-tops.

110 Bird Singing in a Tree 1944
Ink and pencil on white paper $7\frac{1}{2} \times 5\frac{1}{2}$ (19×14)
Inscribed: 'Cecil Collins 1944' b.r.
Not previously exhibited
REPR: Anderson, pl.34
Private Collection

Done in memory of a visionary moment in the garden of Dartington Hall, when the tree in which a singing bird sat seemed to be made from the sound of the song.

111 The Shepherd Fool 1945
Ink and watercolour on white paper $15 \times 22\frac{1}{2}$
(38×57)
Inscribed: 'Cecil Collins/1945' t.l.
EXH: Lefevre 1945 (47); Whitechapel 1959 (201)
REPR: *Malahat Review*, Jan 1970, p.72; *The Vision of the Fool*, 1981, pl.20; Anderson, pl.44
Private Collection

The Shepherd Fool holds on to a living branch while his flock sit peacefully amid a fertile landscape. His flock includes a unicorn and the symbolic meaning of that animal is chastity and purity, both qualities which could be shared by the innocent Fool. A unicorn is sometimes found as guardian of the Tree of Life. Perhaps it is a branch of this which the Shepherd Fool holds tightly.

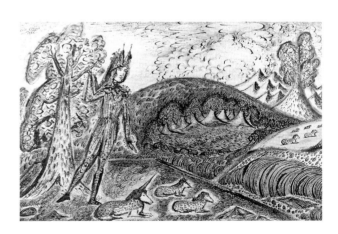

112 The Sun Blessing Stones 1945
Pencil on white paper 22 × 15 (55.9 × 38.1)
Inscribed: 'Cecil Collins/1945' b.r.
EXH: Lefevre 1945 (37); Whitechapel 1959 (206);
Aldeburgh, 1984 (no number)
REPR: *Studio*, Jan 1954, p.20
Private Collection

This used to belong to Norah Nichols, the wife of the poet Robert Nichols, who befriended the Collinses when they first moved to Cambridge.

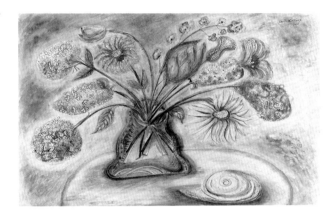

113 Still Life 1945
Ink and watercolour on white paper $15\frac{1}{8} \times 22\frac{1}{4}$
(38.3 × 56.5)
Inscribed: 'Cecil Collins/1945' t.r'
EXH: ? Lefevre 1945 (3) 'Vase of Flowers' or (45)
'Still life' or (48) 'Flowers'; Whitechapel 1959 (203)
Private Collection

Collins turned to still life as a subject in his paintings circa 1932–3, and then it rarely occurred until this work and some other drawings circa 1945. He is thinking of painting some still lifes at the present moment, in 1989.

**114 The Artist and his Wife Walking in a
Landscape** 1945
Pencil on white paper $15\frac{1}{4} \times 22\frac{1}{4}$ (38.7 × 56.5)
Inscribed: 'Cecil Collins 1945' b.r.
EXH: CC Prints, Tate, 1981 (x); *A Paradise Lost*,
Barbican, 1987 (55, repr. pl.15)
Private Collection

A memory of their time in the paradisal garden of Dartington Hall.

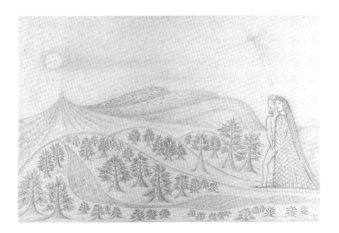

115 **War** 1946
Ink on white paper $12 \times 8\frac{11}{16}$ (30.5 × 22)
Inscribed: 'Cecil Collins/1946' b.r.
EXH: Whitechapel 1959 (209, as 'War I'); CC
Prints, Tate, 1981 (xii); *A Paradise Lost*, Barbican,
1987 (56)
REPR: *Malahat Review*, Jan 1970, p.74;
Anderson, pl.87
Private Collection

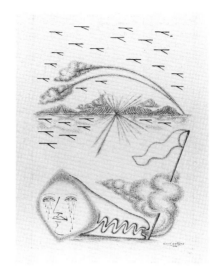

Another drawing entitled 'War II' (whereabouts un-
known) was shown along with this one at the White-
chapel in 1959. A weeping face with shell-like body
grieves in the foreground for the war which is waged
behind the range of mountains in the distance. The sky is
full of robot-like planes among which two shells burst.
From the shell comes a vapour of disgust, directed at the
banner of possessiveness in whose name the battle was
begun. All is not lost, however, because rays of light
issue forth from the horizon.

116 **The Tree of Life** 1946
Ink on white paper $12 \times 8\frac{11}{16}$ (30.5 × 22)
Inscribed: 'Cecil Collins 1946' b.r.
EXH: Whitechapel 1959 (210); CC Prints, Tate,
1981 (xi)
REPR: *Malahat Review*, Jan 1970, p.73
Private Collection

This image of a head conjoined with a tree is first found
in a print of 1944, 'Tree and Hills'; their conjoining
indicates that the spirit of the head and the tree can both
blossom as they are in harmony.

117 **Hymn** 1946
Gouache on white paper $18\frac{1}{2} \times 23\frac{7}{8}$ (47 × 60.6)
Inscribed: 'Cecil Collins/1946' t.l.
EXH: Ashmolean, Oxford, 1953 (17); *Society of
Painters and Sculptors*, Arts Council Gallery,
Cambridge, 1960, (?); Hamet 1972 (26); *A Paradise
Lost*, Barbican, 1987 (57, repr. pl.11)
REPR: *Universidad de Mexico*, Aug 1956, p.32
Private Collection

The four figures on the right dressed in ritual, highly
ornamented costumes call forth the two figures on the
left at the moment of the rising of the sun over the
mountains. The foreground figure on the left has a
faceted body and a flaming mane and denotes masculine
energy. When this figure is echoed in the background it is
softer in shape and appearance.

118 Enthroned Figure 1947
Gouache on white paper $15\frac{3}{4} \times 12\frac{1}{4}$ (40×31)
Inscribed: 'Cecil Collins/1947' b.r.
EXH: Lefevre, March 1948 (14); *Yorkshire Artists'*
Exhibition, Leeds City Art Gallery, 1949 (200);
Heffer Gallery, Cambridge 1951 (10)
REPR: Anderson, pl.35
Bryce McKenzie-Smith

The harsh and acute facets which make up the figure are
redeemed by the softness of ripping hair or light waves
that flow down from the head. The figure wears a many-
pointed cap, rather like a fool.

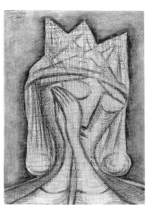

119 Landscape: Moonlight 1947
Gouache on white paper 16×19 (40.7×48.2)
Inscribed: 'Cecil Collins/1947' t.r.
EXH: Lefevre, March 1948 (23); *Yorkshire Artists'*
Exhibition, Leeds City Art Gallery, 1945, (99);
Hamet 1972 (27, repr.[p.12])
Private Collection

Painted at Hollins, Luddenden, Yorkshire. The winter
of 1947 was a terrible one and this snowy landscape was
the result of collected impressions gained on walks
through the cold landscape. The snow light and the
moon light combine to give the landscape an ethereal
quality.

120 Fool Praying 1947
Watercolour and chalk on white paper $14\frac{1}{2} \times 10\frac{1}{2}$
(36.8×26.7)
Inscribed: 'Cecil Collins/1947' t.l.
EXH: Lefevre, March 1948 (1); Whitechapel 1959
(212)
REPR: *The Vision of the Fool*, 1981, pl.10
Private Collection

121 Head of a Fool 1949
Gouache and ink on white paper 22×15
(55.9×38.1)
Inscribed: 'Cecil Collins/1949' t.r.
EXH: *Summer Exhibition*, Gimpel Fils, 1949 (45);
A Paradise Lost, Barbican, 1987 (58)
REPR: *The Vision of the Fool*, 1981, col.pl.III
Private Collection

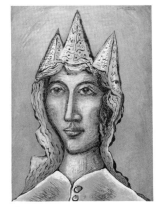

120 121

122 The Resurrection 1952
Pencil on white paper $30\frac{1}{8} \times 20\frac{1}{8}$ (76.5 × 51)
Inscribed: 'Cecil Collins/1952' b.r.
EXH: Leicester Galleries 1956 (23); Whitechapel
1959 (219); Aldeburgh, 1984 (no number)
REPR: *Malahat Review*, Jan 1970, p.75;
Anderson, pls.56 and 57
Private Collection

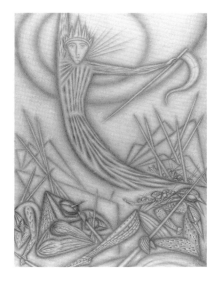

From 1951 to 1954 Collins found that he made use of
Christian imagery, though with no reason or pro-
gramme in mind. With hindsight he is glad to have
worked through such particular imagery in order to
exorcize himself of it. This work, (along with cat.
nos.123, 124, 125 and 34) resulted from that period.
Christ, at his moment of rebirth, wears a multi-pointed
crown reminiscent of a fool's hat. The soft curves of the
upper half of the composition are contrasted with the
harsh angular forms below.

123 Angel Paying Homage to Christ 1952
Ink and watercolour on white paper $29\frac{15}{16} \times 21\frac{7}{8}$
(76 × 55.5)
Inscribed: 'Cecil Collins/1952' t.l.
EXH: Leicester Galleries 1956 (20); Whitechapel
1959 (218)
REPR: Anderson, pl.54
Private Collection

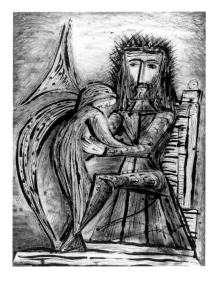

Christ sits enthroned wearing a plum coloured robe and
extends his arms to a yellow robed angel that bows its
head. The angel is supported by its wing tip which
touches the ground and by its robe which comes to rest
on Christ's foot. The strong square head of Christ is
seen again in the painting, 'Christ Before the Judge'
(cat.no.34).

124 The Crucifixion 1952
Brown ink on grey paper $28\frac{3}{8} \times 10\frac{11}{16}$ (72 × 52.5)
Inscribed: 'Cecil Collins/1952' b.r.
EXH: Leicester Galleries 1956 (35); Whitechapel
1959 (217, repr. pl.x)
LIT: *New Fire*, Vol.5, no.38, Spring 1979,
pp.266–70, repr. p.266.
REPR: *Universidad de Mexico*, Aug 1956, p.32;
Anderson, pl.55
Private Collection

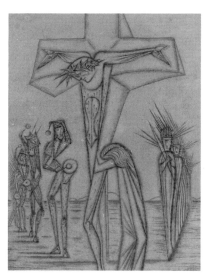

The crucified Christ bends his head as if in greeting to a
band of musician fools who attend him. A vicious
regimented army wait on his other side.

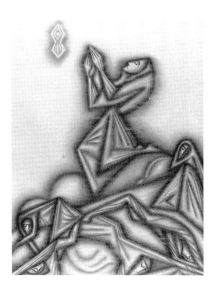

125 The Agony in the Garden 1956
Pencil on white paper $30\frac{1}{8} \times 20\frac{1}{8}$ (76.5 × 51)
Inscribed: 'Cecil Collins/1956' b.r.
EXH: Whitechapel 1959 (223, repr. pl. XIV);
Aldeburgh, 1984 (no number)
REPR: Anderson, pl. 58
Private Collection

The disciples are only distinguished by their five faces,
their bodies sink into the landscape. Three times in the
garden Christ prayed that the cup or chalice of sacrifice
might pass from him, while his disciples slept.

126 Angel Comforting a Fool 1957
Gouache on white paper $12\frac{1}{4} \times 14\frac{7}{8}$ (54 × 39)
Inscribed: 'Cecil Collins/1957' b.r.
EXH: Whitechapel 1959 (116 with different
dimensions)
REPR: *The Vision of the Fool*, 1981, col. pl. IV
Private Collection

126 127

127 Exotic Birds 1958
Gouache on brown paper $21\frac{3}{4} \times 14\frac{5}{8}$ (55.5 × 37.1)
Inscribed: 'Cecil Collins/1958' b.r.
Not previously exhibited
Private Collection

Three brilliantly patterned birds perch on tree and stone
forms in the foreground. Two fly in the sky above. The
composition was arrived at by allowing the forms to
grow and complement one another.

128 Landscape: Aix en Provence 1958
Watercolour and chalk on paper $5\frac{3}{4} \times 8\frac{1}{2}$
(14.7 × 21.6)
Inscribed: 'Cecil Collins/1958' b.r.
EXH: Hamet 1972 (41)
Private Collection

Done in memory of a visit to the South of France. The
palette of this work is hotter as a result.

129 Head of a Woman 1960
Charcoal on white paper $11\frac{1}{4} \times 10\frac{1}{2}$ (28.6×26.7)
Inscribed: 'Cecil Collins/1960' b.r.
Not previously exhibited
Private Collection

This figure is seen in profile view, facing left. The sweeping charcoal line is 'matrical' in inspiration.

130 Figure Carrying the Chalice of the Sun 1960
Black chalk and gouache on white paper $21 \times 14\frac{3}{8}$
(53.3×36.5)
Inscribed: 'Cecil Collins/1960' b.r.
Not previously exhibited
Private Collection

A figure, neither male nor female but with strong muscular arms, carries a chalice which gives off flames. These wrap around the head which is like a round sun. The strength of the figure is like that of 'The Oracle' (cat.no.89).

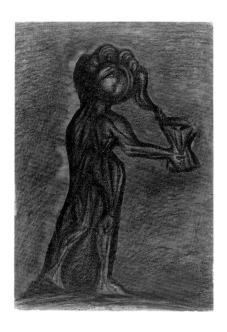

131 Dancers 1960
Brown ink on cream paper $19 \times 12\frac{3}{8}$ (48.2×31.4)
Inscribed: 'Cecil Collins/1960' b.r.
Not previously exhibited
Private Collection

This drawing was executed with a quill pen, as was 'Two Women' (cat.no.132). The first marks made were the strong linear ones, which were created freely in a 'matrical' manner; then clusters of small marks were added to give tone, which Collins says is of a musical rather than a formal nature.

132 Two Women 1960
Black and blue ink, pencil and blue chalk on cream paper $8\frac{3}{4} \times 6$ (22.2×15.2)
Inscribed: 'Cecil Collins/1960' b.l.
Not previously exhibited
Private Collection

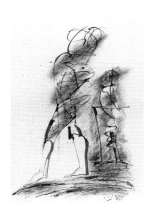
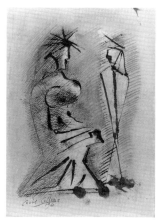

131 132

133 Wisdom Leading the People 1968
 Pencil on white paper 5 × 6 (12.7 × 15.2)
 Not inscribed
 EXH: Royal Academy Diploma Galleries, 1968
 (584)
 REPR: *OUP Illustrated Old Testament*, p.155
 Private Collection

This illustrates ideas from Chapter 10 of *The Wisdom of Solomon*.

134 The Vision of Ezekiel 1968
 Pencil on white paper $9\frac{1}{2}$ × 6 (24.1 × 15.2)
 Not inscribed
 EXH: Royal Academy Diploma Galleries, 1968
 (491)
 REPR: *OUP Illustrated Old Testament*, p.273
 Private Collection

This represents Ezekiel's vision from Chapter 1, the book of *Ezekiel*.

135 The Healing of the Sanctuary 1976
 Pencil on white paper $12\frac{1}{4}$ × 9 (31.1 × 22.9)
 Inscribed: 'Cecil Collins 1976' b.r.
 EXH: d'Offay Gallery 1976 (19); Plymouth, 1983
 (28, repr. [p.7]) *Temenos Exhibition*, Dartington,
 1986 (no number)
 REPR: Anderson, pl.107
 Dartington Hall Trust

An angel stands as guardian to the curtained sanctuary. Above the sanctuary is a white cloud, which from childhood days has symbolised the doorway to paradise for Collins.

136 Angel 1976
 Pencil on white paper 16 × 12 (40.6 × 30.5)
 Not inscribed:
 EXH: d'Offay Gallery 1976 (18)
 Private Collection

As the angel descends to our earth, the tufts of grass are blown over by her power.

137 Fool 1976
 Pencil on white paper 11½ × 9¾ (29.2 × 24.7)
 Inscribed: 'Cecil Collins 1976' b.r.
 EXH: d'Offay Gallery 1976 (14): *Rocks and Flesh*,
 Norwich 1984 (8)
 Private Collection

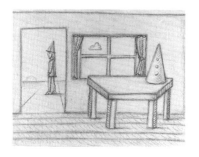

138 The Afternoon of the Fools II 1976
 Pencil on white paper 8 × 9½ (20.3 × 24.2)
 Inscribed: 'Cecil Collins/1976' b.l.
 EXH: d'Offay Gallery 1976 (24)
 REPR: *The Vision of the Fool*, 1981 pl.14;
 Anderson, pl.5
 David Batterham

The afternoon was for the artist the most special time of the day; it seemed to Collins to reach its peak then as the taking of tea was an important ceremony in his West Country childhood. Collins also remembers being impressed by the quiet hallway of houses, especially hallstands with hats and other objects placed on them, for use by their owners. The Fool has gone out into the afternoon sun, and his other hat awaits him on the table. This work is one of the cycle of Rooms of Childhood.

139 Two Fools Dancing 1976
 Pencil on white paper 11 × 9 (27.9 × 22.9)
 Inscribed: 'Cecil Collins/1976' b.r.
 EXH: d'Offay Gallery 1976 (7)
 Jonathan Stedall

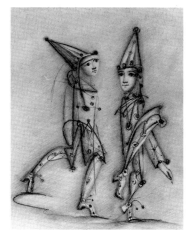

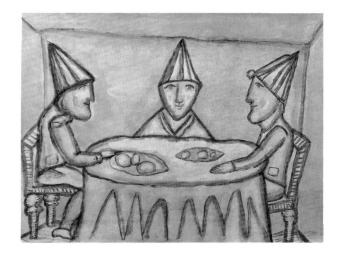

140 The Feast of Fools 1979
Gouache on white paper 18 × 23¼ (45.7 × 59.1)
Inscribed: 'Cecil Collins/1979' b.r.
EXH: d'Offay Gallery 1981 (52); Plymouth 1983
(23, repr. [p.15]); Aldeburgh, 1984 (no number)
REPR: *The Vision of the Fool*, 1981, pl.17
Private Collection

This work is partly about food. Collins believes we are
what we eat, and that pictures are a form of food. It also
has a relationship with Christ's Last Supper, taken with
his disciples in an upper room. Here the Fools sit in
peace and happiness at a round table, like that used by
Arthur and his knights. Fools are on a great adventure
like knights. The chevrons of the table cloth echo the
pointed hats of the Fools.

141 The Divine Land 1979
Gouache, watercolour and ink on white paper
16 × 23 1/16 (40.6 × 58.5)
Inscribed: 'Cecil Collins 1979' b.l.
EXH: d'Offay Gallery 1981 (51); *The Hard-Won
Image*, Tate, 1984 (39)
LIT: *The Tate Gallery 1980-82, Illustrated
Catalogue of Acquisitions*, 1984, pp.71–3 (repr.)
REPR: *Temenos*, 1, 1981, opp. p.77; Anderson,
pl.6
Tate Gallery

As the angel passes over the mountain which is in the
form of a transparent curtain, it causes it to tremble and
thus to initiate an unveiling. This curtain is related to the
one blown aside by the Sibyl in cat.no.97, and the one
firmly in place in 'The Healing of the Sanctuary'
(cat.no.135).

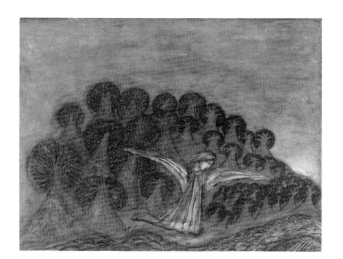

142 By the Waters 1980
Gouache on white paper 18⅛ × 23¼ (46 × 59)
Inscribed: 'Cecil Collins 1980' b.l.
EXH: d'Offay Gallery 1981 (59)
REPR: Anderson, col.pl.73 as 'Beside the Waters';
Resurgence, no.128, May–June 1988, pp. 30–1 in
col.
Private Collection

An angel contemplates the healing waters of a river in
front of a fertile and wooded landscape lit by the rays of
a summer moon.

143 Morning Star 1981
Gouache on white paper 18 × 23¼ (45.7 × 59.1)
Inscribed: 'Cecil Collins/1981' b.r.
EXH: d'Offay Gallery 1981 (72); Plymouth 1983
(24); Aldeburgh 1984 (no number); *Temenos
Exhibition*, Dartington Hall, 1986 (no number)
REPR: Anderson, col.pl.93 as 'The Morning Star'
Dartington Hall Trust

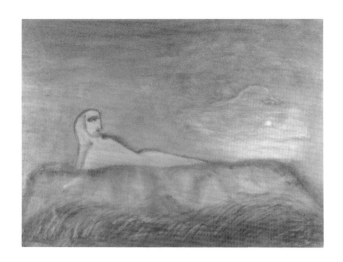

A soul in a relationship with the earth gazes eastward
and regards the morning star, which precedes the dawn.
Job, Chapter 38, v.4 & v.7 states 'Where wast thou when
I laid the foundations of the earth? When the morning
stars sang together and all the sons of God shouted for
joy?'

144 Conversation between Two Fools 1981
Brown ink on white paper 5⅛ × 3¼ (13 × 8.2)
Inscribed: 'Cecil Collins 1981' b.r. and with title,
medium, date of 'April 25th 1981', and address on
back
Not previously exhibited
Private Collection

145 The Fool 1982
Tempera on white paper 5¾ × 5⅜ (14.6 × 13.7)
Inscribed: 'Cecil Collins/1982' b.r.
Not previously exhibited
Private Collection

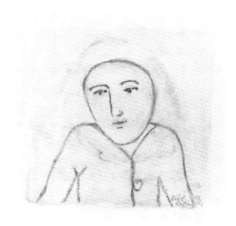

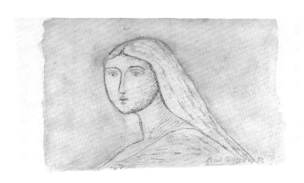

146 **Head of a Girl** 1982
Brown ink and wash on cream paper $5\frac{1}{8} \times 8$
(13×20.3)
Inscribed: 'Cecil Collins 1982' b.r.
Not previously exhibited
Private Collection

147 **Sheet of Studies** 1988
Gouache and pencil on white paper 8×5
(20.3×12.7)
Inscribed: 'Cecil Collins/1988' b.l.
Not previously exhibited
Private Collection

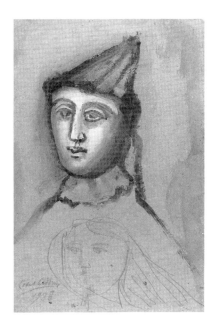

How often, have we, in secret, wept over you,
O Face of Paradise.

Cecil Collins
Poem XVIII, from In the Solitude of this Land

Parle, voix Lointaine, monde secret . . .

Brentano

Speak, distant voice, secret world . . .

Brentano

Bibliography

compiled by Jane Savidge

(Items marked with an asterisk have not been seen by the compiler)

1 Writings by the artist

1935

Foreword to the catalogue of *Exhibition of paintings and drawings*, held London, Bloomsbury Gallery, 1935, p.1.

1936

Poetry. *New English Weekly*, 20 Feb. 1936, p.370.

1937

[Reply to criticism of the exhibition held Dartington, Barn Studio, June–July 1937]. *News of the Day*, [Dartington Hall Newsletter], no.795, 25 July 1937, p.3.

1945

The anatomy of the fool. *Transformation*, no.3, 1945, pp.25–8.

1947

The Vision of the Fool. [London]: Grey Walls Press, 1947. 31p.; 31 leaves of plates.

1959

Notes in the catalogue of *Cecil Collins: a retrospective exhibition*, held London, Whitechapel, 1959, p.5.

1964

Art and modern man. *Tomorrow: the Journal of Parapsychology, Cosmology and Traditional Studies*, Autumn 1964, vol.12, no.4, pp.319–326.

1968

Statement. *The Oxford illustrated Old Testament with drawings by contemporary artists*. London: Oxford University Press, 1969, 5v. vol.2, p.519. Statement reprinted in each vol. and in the catalogue of *The Oxford Old Testament drawings*, exhibition held London, Royal Academy of Art Diploma Gallery, June–Aug. 1968, p.11.

1972

Notes in the catalogue of *Cecil Collins: retrospective exhibition*, held London, Hamet Gallery, 1972, pp[7–8].

1976

Introduction to the catalogue of *Cecil Collins: new drawings*, held London, Anthony d'Offay, 1976, pp.[1–2].

1977

Politics are incapable of creating a culture: [extract from: *The vision of the fool* (1947)], in *Towards another picture: an anthology of writings by artists working in Britain 1945–1977*, ed. by Andrew Brighton and Lynda Morris. Nottingham: Midland Group, 1977, pp.229–30.

1981

In the solitude of this land: poems 1940–81. Ipswich: Golgonooza Press, c.1981. 24p. Limited ed. of 100 signed numbered copies.

The vision of the fool. [2nd ed.]. Chipping Norton: Anthony Kedros, 1981. 40p., illus.

Introduction to the catalogue of *Cecil Collins: new works*, held London, Anthony d'Offay, 1981, p.1.

1987

Some notes by the artist, in *A paradise lost: the neo-romantic imagination in Britain 1935–55*, held London, Barbican Art Gallery, 1987, p.109.

1988

[Reminiscences of 1927–31 at the Royal College of Art], in the catalogue of *Exhibition Road*, held Royal College of Art, 1988, pp.78–9.

1989

Foreword in, *The living tree: art and the sacred*, by John Lane. Hartland: Green Books, 1989. p.ix

2 Books and articles illustrated by the artist

1944

Wrey Gardiner. *The gates of silence*: [poems]. London: Grey Walls Press, 1944. Drawings facing pp.37; 54.

1945

Counterpoint, vol.2, [1945], cover design.

1948

Nicholas Moore. *Buzzing around with a bee and other poems*. London: Poetry Library, [1948?]. Cover design. (PL Pamphlets; no.4).

1968

Kathleen Raine. *Six dreams and other poems*. London: Enitharmon Press, 1968. Frontispiece.

The Oxford illustrated Old Testament with drawings by contemporary artists. Oxford: Oxford University Press, 1968. 5v. Illus. vols.2–5.

1981–

Temenos vols.1–5. London: Temenos, 1981–1984. Cover design.

1986

Peter Riley Books. *Catalogue 19: The library of Nicholas Moore*. Cambridge: Peter Riley Books, 1986. Cover design. Untitled drawing originally intended for a Nicolas Moore pamphlet c.1941 but unpublished.

3 Broadcasts

1959

6 Dec. [Review of the 1959 Whitechapel exhibition]. *The Critics*, produced by Peggy Barker; conducted by Philip Hope-Wallace participants: Roger Manvell, Harold Hobson, Pamela Hansford Johnson, Eric Newton and Cyril Ray. Radio Broadcast, The Home Service.

1978

The eye of the heart – the paintings of Cecil Collins, directed by Stephen Cross. London: Arts Council, *c*.1978. Film. 48 mins. col. 16mm.

1981

Oct. [Cecil Collins interviewed by Edward Lucie-Smith]. *Conversations with artists II*. Radio broadcast, Radio 3.

1984

8 Apr. *One pair of eyes: fools and angels*, directed by Christopher Sykes; produced by Jonathan Stedall. Television broadcast, BBC 2.

1988

11 Mar. [Interview about the Royal College of Art for the Exhibition Road exhibition]. *ITN News*. Television broadcast. Channel 4.

23 May. [Review of the 1988 d'Offay exhibition and 'Cecil Collins: the quest for the great happiness' by William Anderson]. *Currents*, directed by Tim Jones, produced by Simon Westcott. Television broadcast, Thames Television.

24 May 1988. [Review of the unveiling of 'The Mystery of the Holy Spirit' West Window, All Saints Church, Basingstoke. Interviews with Cecil Collins, Patrick Reyntiens and William Anderson]. *Kaleidoscope*. Radio broadcast. Radio 4.

30 May, [Julian Spalding in conversation with Cecil Collins]. *Third Ear*. Radio broadcast. Radio 3.

1989

*May. [Cecil Collins], produced by Judith Bumpus; presented by Bryan Robertson. Radio broadcast. Radio 3.

*May? *Hymn of light*, directed by Patrick McCreanor; co-produced by Harry Marshall and Patrick McCreanor (John Peel Productions); presented by Peter Levi. Television broadcast. Channel 4 (Art, faith and vision series).

4 One-Man Exhibitions

1935

Oct. London, Bloomsbury Gallery. *Exhibition of paintings and drawings by Cecil Collins*. (36 works). [4]p. Foreword by the artist.

1937

June–July. Dartington, Barn Studio. *Cecil Collins: exhibition of paintings and drawings*. (65 works) 4p., illus on cover.

1944

Feb. London, Lefevre Galleries. *Cecil Collins*. (50 works). [4]p., illus. Foreword.

1959

Nov.–Dec. London, Whitechapel Art Gallery. *Cecil Collins: a retrospective exhibition of paintings, drawings and tapestries from 1928–1959*. (227 works). 22p., illus. Preface B.R. [Bryan Robertson].

1961

Sept. Athens, Zygos Gallery. *Exhibition of watercolours and lithographs*. (54 works). 2p.

1965

Feb.–Mar. London, Arthur Tooth & Sons. *Cecil Collins recent paintings*. (31 works). [14]p., illus. Introd. Kathleen Raine; notes by the artist.

1966

*Nov.–Dec. Chilham, Canterbury, Robins Croft Gallery. [One man exhibition]. No catalogue.

1967

Mar. London, Crane Kalman Gallery. *Gouaches and watercolours by Cecil Collins*. (26 works). [8]p., illus.

1971

Sept.–Oct. London, Arthur Tooth & Sons. *Cecil Collins recent paintings*. (30 works). [14]p., illus. Avant propos James Hillman.

1972

Nov. London, Hamet Gallery. *Cecil Collins: retrospective exhibition*. (62 works). [22]p., illus. Notes by the artist.

1975

*June. Dartington, Dartington Hall. [*Corridor display on the occasion of the lecture 'The Vision of the Angel and the Fool' given by the artist, 10 June 1975.*] No catalogue.

1976

June–July. London, Anthony d'Offay. *Cecil Collins: new drawings*. (26 works). [6]p. Introd. by the artist.

1981

Aug.–Nov. London, Tate Gallery. *The prints of Cecil Collins*. (74 works). 28p. + list of works, illus. Text by Richard Morphet.

Oct.–Nov. London, Anthony d'Offay. *Cecil Collins: new works*. (73 works). [10]p. [4] leaves. Introd. by the artist.

1983

Nov.–Dec. Plymouth, Arts Centre. *Tribute to Cecil Collins*. (40 works). [20]p.; illus. Introd. by John Lane.

1984

[June]. Aldeburgh, Festival Gallery. *Cecil Collins*. (44 works). 3 leaves.

1988

June. London, Anthony d'Offay. *The music of dawn: recent paintings by Cecil Collins*. (32 works) 30p. illus. Introd. by William Anderson.

5 Group exhibitions

1927?

*Plymouth. [Group exhibition]. (1 work). No catalogue traced.

1928

Oct.–Nov. London, Victoria and Albert Museum. *Royal College of Art Sketch Club exhibition*. (2 works). 23p. Foreword by William Rothenstein.

1936

June–July. London, New Burlington Galleries. *The International Surrealist exhibition*. (2 works). 31p. Pref. by André Breton; introd. Herbert Read.

1939

Jan.–Mar. Leeds, City Art Gallery. *Yorkshire artists' exhibition*. (2 works). 10p

1940

Mar.–Apr. Dartington, Barn Studio. *Panorama*. (1 work). 4p. Introd. by C.C. Martin.

1942

Toledo (Ohio), Museum of Art. *Contemporary British art*. (1 work). 65p., illus. Foreword by Blake-More Godwin. Organised by the British Council. Tour of pictures shown in the British Pavilion at the New York World Fair, 1939.

Mar.–May. London, London Museum. *New movements in art: contemporary work in England: an exhibition of recent paintings and sculpture*. (1 work). [42]p. Foreword E.H.R.

Apr.–May. London, Leicester Galleries. *Imaginative art since 1939*. (6 works). 12p.

June. Dartington, Barn Studio. [*Exhibition of modern paintings largely drawn from the Elmhirsts collection*]. (1 work). No catalogue. List of works in *News of the Day* [Dartington Hall Newsletter], no.1223, 19 June 1942, p.1.

1945

Jan. Gezira, Royal Agricultural Hall. *Exhibition of contemporary British art*. (1 work). [44]p. Organised by the British Council.

Dec. London, Lefevre Galleries. *New watercolours and drawings: Cecil Collins; Katharine Church: watercolours and gouaches*. (67 works). [4]p.

1947

*Dublin, Waddington Galleries. *Contemporary British watercolours*. (1 work). No catalogue traced.

Apr.–June. New York, Brooklyn Museum. *14th biennial international water color exhibition*. (2 works). 28p.

1948

Mar. London, Lefevre Galleries. *New paintings by Cecil Collins and new paintings by Robert Medley*. (32 works). 4p.

[Mar.?]. London, Arts Council. *A selection of paintings and drawings acquired by the Contemporary Art Society*. (1 work). 16p. Introd. by Colin Anderson.

Mar.–Apr. Vienna, Albertina Museum. *Englische Graphik und Aquarelle Kunst*. (1 work).

1949

*Cambridge, Magdalene College, Benson Hall. *Contemporary painting and sculpture*. No catalogue traced.

London, Arts Council. *The East Anglian scene: an exhibition by contemporary artist*. (1 work). [8]p. Introd. by Lynton Lamb.

Aug. London, Gimpel Fils. *Summer exhibition*. (1 work). 3p.

Sept.–Nov. Leeds, City Art Gallery. *Yorkshire artists' exhibition*. (2 works). 11p.

Oct.–Nov. Cambridge, Heffer Gallery. *Modern British painting 1900–1949*. (2 works). 7p. Introd. by John Rothenstein.

1950

*Bradford, Cartwright Hall. [*Group exhibition*]. (1 work).

*Edinburgh, Dovecote Tapestries. *Saltire Society Exhibition*. No catalogue traced.

London, Arts Council. *Recent tapestries: woven by the Edinburgh Tapestry Company*. (2 works). 4p. Introd. by Philip James.

Jan.–Feb. Cambridge, Heffer Gallery. *New paintings by Francis Rose, Cecil Collins and Merlyn Evans*. (18 works). [6]p. Foreword Kathleen Raine.

*Feb.–Mar. Cambridge, Heffer Gallery. *Young British painters*. (1 work). No catalogue traced.

*Apr.–May. Cambridge, Heffer Gallery. *Recent paintings by Thelma Hulbert and new lithographs by English artists*. (1 work). No catalogue traced.

*May. Cambridge, Guildhall. *Exhibition of the Cambridge Drawing Society*. (1 work). No catalogue traced.

*Oct. Cambridge. *Watercolours*. (1 work). No catalogue traced.

1951

Apr.–May. Cambridge, Heffer Gallery. *The first exhibition of recent paintings in oil by Cecil Mullins; and an anthology of contemporary art: pictures for colleges*. (1 work). 4p.

June. Cambridge, Heffer Gallery. *A Festival exhibition of paintings and drawings by French and English artists*. (1 work). [2]p.

Sept.–Nov. Leeds, City Art Gallery. *Yorkshire artists' exhibition* (2 works). 12p.

Nov. London, Leicester Gallery. *Recent pictures by Mary Potter. New paintings by Cecil Collins*. (46 works). 11p. (Exhibition no.972).

1952

Apr.–May. Cambridge, Heffer Gallery. *Graphic art in England today*. (4 works). [4p.].

May–June. Cambridge, Arts Council Regional Exhibition Room. *4 contemporaries: Edward Bawden, Prunella Clough, Cecil Collins, Michael Rothenstein*. (7 works). [5]p.

May–June. Cambridge, Heffer Gallery. *Art in Cambridge: an exhibition of paintings, sculpture and pottery by local artists*. (3 works). [8p.].

Dec. London, New Burlington Galleries. *The mirror and the square: an exhibition of art ranging from realism to abstraction*. (2 works). 10p. Organised by the A.I.A.

1953

*Jan.–Feb. Cambridge, Heffer Gallery. *Ceramic figures by Audrey Blackman and recent work by young contemporary painters*. No catalogue traced.

Mar.–Apr. Portsmouth, Cumberland House Museum and Art Gallery. *The mirror and the square*. (1 work). 6p.

Apr.–May. London, Royal Institute of British Architects. *2nd exhibition by the Society of Mural Painters*. (1 work). 6p.

Apr.–May. London, Whitechapel Art Gallery. *20th century form: painting, sculpture and architecture*. (1 work). 16p. Introd. by Bryan Robertson; Trevor Dannatt.

July–Aug. Cardiff, National Museum of Wales. *British romantic painting in the twentieth century*. (1 work). 18p. 12p. of plates. Introd. by John Petts. Organised by the Welsh Arts Council. Travelling to Aberystwyth, National Library of Wales; Swansea, Glynn Vivian Art Gallery (to Oct. 1953).

Sept.–Oct. Eastbourne, Towner Art Gallery. *Mural paintings*. (1 work). 4p.

Sept.–Nov. Leeds, City Art Gallery. *Yorkshire artists' exhibition*. (1 work). 10p.

Oct. Oxford, Ashmolean Museum. *Exhibition of paintings and sculpture by Cecil Collins, Willi Soukop and Anthony Whishaw*. (23 works). 4p. Organised by Oxford University Art Club.

Nov.–Dec. London, Tate Gallery. *Figures in their setting painted at the invitation of the Contemporary Art Society*. (1 work). [12]p.

1954

London, Arts Council. *Recent British painting*. (2 works). 17p. Introd. by John Commander.

Mar.–June. Bradford, Cartwright Memorial Hall. *Golden Jubilee exhibition 1904–1954: 'Fifty years of British art'*. (1 work). 42p.

Jul.–Aug. London, Guildhall Art Gallery. *Trends in British art 1900–1954*. (1 work). 12p. Introd. by Raymond Smith.

Sept.–Oct. London, Whitechapel Art Gallery. *British painting and sculpture 1954*. (1 work). [16]p.

Jan.–Feb. London, Whitechapel Art Gallery. *Pictures for schools: an exhibition sponsored by the Society for Education through Art*. (1 work). 7p.

1955

London, Arts Council. *Some twentieth century English watercolours*. (1 work). 6p.

Jan.–Mar. Leeds, City Art Gallery. *Yorkshire artists' exhibition*. (2 works). 11p.

Mar. London, Contemporary Art Society. *Catalogue of the greater portion of a collection of modern English paintings, watercolours,*

BIBLIOGRAPHY

drawings and sculpture belonging to W.A.Evill displayed to members of the Contemporary Art Society at 39 Eton Avenue, Hampstead, London. (1 work). 11p.

1956

Jan. Palm Beach, Society of the Four Arts. *Contemporary British painting.* (6 works). 28p. Introd. by Sir John Rothenstein. Travelling to Coral Gables, University of Miami, Havana, Patronato de Bellas Artes y Museos Nacionales; Birmingham, (Alabama), Museum of Art (to June 1956).

*[Feb.] London, Edinburgh Weavers Mount Street Showroom. [Exhibition]. No catalogue traced.

Feb. London, Leicester Galleries. *Catalogue of the exhibitions Eliot Hodgkin recent tempera paintings. Terry Frost new paintings. Cecil Collins: new paintings and drawings.* (37 works). 15p. (Exhibition no.1084).

1957

Jan.-Mar. Leeds, City Art Gallery. *Yorkshire artists' exhibition* (2 works). 12p.

[Jul.] London, St. George's Gallery. *British graphic art.* (1 work). [12]p., illus. Introd. by Robert Erskine.

Nov.-Jan. 1958. Liverpool, Walker Art Gallery. *The John Moore's Liverpool exhibition.* (1 work). 20p. Prizewinner: Open Section.

1958

London, Gimpel Fils. *Contemporary tapestries woven by Ronald Cruickshank in Edinburgh.* (1 work). 6p.

Mar.-Apr. London, R.B.A. Galleries. *AIA 25.* (1 work). 16p. Introd. by A.F. Organised by the A.I.A.

May-June. London, Whitechapel Art Gallery. *The Guggenheim painting award.* (1 work). [2]p. typescript.

Jul.-Aug. London, Tate Gallery. *The Religious theme: an exhibition of painting and sculpture.* (1 work). [14]p. Foreword by Colin Anderson. Organised by the Contemporary Art Society.

1959

Apr. London, AIA Gallery. *Sixteen painters.* (1 work). 1p. Introd. by Adrian Heath.

1960

*London, Guild of Catholic Artists and Craftsmen. *Guild of Catholic Artists and Craftsmen exhibition.* (2 works). Cecil Collins an invited artist.

*Cambridge, Arts Council Gallery. *Society of Painters and Sculptors annual exhibition.* (1 work). No catalogue traced.

*May. London, ABC Gallery. [Opening exhibition]. (1 work). No catalogue traced.

1962

Oct.-Nov. Cardiff, National Museum of Wales. *British art and the modern movement 1930-1940.* (4 works). 40p., illus. Introd. by Alan Bowness. Organised by the Arts Council Welsh Committee.

1963

Dec.-Jan. 1964. London, Crane Kalman Gallery. *The Englishness of English painting: a personal anthology.* (3 works). [20]p., illus.

1964

Mar.-Apr. New York, Osborne Gallery. *The Englishness of English painting: a personal anthology.* (6 works). 28p., illus. Introd. by A.Kalman.

Oct.-Jan. 1965. Pittsburgh, Carnegie Institute. *Pittsburgh International exhibition of contemporary painting and sculpture.* (1 work). [84]p.

1965

Nov.-Dec. London, Crane Kalman Gallery. *Paintings of 'Silence'.* [No list of works]. 1 folded card. illus.

1967

*Jul.-Aug. Cambridge, Guildhall. *Cambridge Festival: open exhibition of paintings and sculpture.* (1 work). No catalogue traced.

Nov.-Jan. 1968. London, Crane Kalman Gallery. *Modern British paintings.* (2 works). 22p., illus.

1968

June-Aug. London, Royal Academy of Arts. *The Oxford Old Testament drawings.* (13 works). 88p., illus. Statement by the artist.

1969

May. Edinburgh, Scottish National Gallery of Modern Art. *British drawings 1939-49.* (2 works). 3 leaves.

1971

Nov. London, Hamet Gallery. *Britain's contribution to surrealism of the 30's and 40's.* (6 works). 44p., illus.

1972

May. Cambridge, Magdalene Street Gallery. *Art in England 1900-1945.* (1 work). 2 leaves.

1974

Dec.-Jan. 1975. London, Crane Kalman Gallery. *British paintings a personal selection.* [No list of works]. 1 folded card [4p.].

1977

Mar.-Apr. London, Crane Kalman Gallery. *A selection of British paintings.* [No list of works]. 1 folded card. 4p.

Dec.-Jan. 1978. London, Crane Kalman Gallery. *British paintings: a personal selection.* [No list of works]. 1 folded card. 4p.

1979

Oct.-Jan. 1980. London, Hayward Gallery. *Thirties.* (2 works). 320p., illus. Organised by the Arts Council.

1980

Jul.-Aug. Harrogate, Sotheby Parke Bernet. *An exhibition of the Contemporary Art Society's gifts to Yorkshire 1920-1980.* (1 work). 7p. Organised by the Contemporary Art Society.

1984

Jul.-Sept. London, Tate Gallery. *The hard won image: traditional method and subject in recent British art.* (8 works). 80p., illus. Text by Richard Morphet.

1985

Sept.-Oct. Norwich, School of Art Gallery. *Rocks and flesh: an argument for British drawing.* (2 works) 85p., illus. Selected and introd. by Peter Fuller.

1986

Mar.-Apr. London, Mayor Gallery. *British surrealism fifty years on.* (1 work). 71p., illus. Text by Michael Remy.

Apr. London, St. Botolph's Aldgate. *Resurrection and new life.* (1 work). 16p. Introd. Kathleen Raine.

Oct.-Dec. Leeds, City Art Galleries. *Angels of anarchy and machines for making clouds: Surrealism in Britain in the thirties.* (2 works). 214p., illus. Text by Alexander Robertson . . . [et al.].

Oct.-Nov. Dartington, Dartington Hall. *The Temenos exhibition: work by past and future contributors to Temenos.* (6 works). typescript list.

1987

May-July. London, Barbican Art Gallery: *A Paradise lost: the neo-romantic imagination in Britain 1935-55.* (19 works). 144p., illus. Edited and with text by David Mellor; with essays by Andrew Crozier . . . [et al.].

1988

Mar.–Apr. London, Royal College of Art. *Exhibition Road: painters at the Royal College of Art.* (3 works). 176p., illus. Edited by Paul Huxley; texts by Andrew Brighton . . . [et al.].

Apr.–May. London, Richard Pomeroy. *A green thought in a green shade: an exhibition of contemporary imaginative landscape.* (1 work). card. + 1p.

Aug.–Oct. Bristol, Arnolfini Gallery. *Maria Gilissen: portrait photography.* 38p. Includes a photograph of Cecil Collins.

Sept.–Oct. London, Nigel Greenwood Gallery. *Jeffery Camp: a personal choice: 25 artists.* (2 works). 12p. Exhibition selection and introd. by Jeffery Camp.

1989

Jan.–Apr. London, Tate Gallery. *Portrait of the artist: artists' portraits published by 'Art News and Review' 1949–1960.* (1 work). 143p., illus. Text by David Fraser Jenkins and Sarah Fox-Pitt.

Mar.–Apr. London, Long & Ryle. *The sacred in art.* (1 work) No catalogue published.

6 Books and sections of books about the artist

Anderson, William. *Cecil Collins: the quest for the great happiness.* London: Barrie & Jenkins, 1988. 192p., illus.

Basingstoke, St. Michael and All Saints Church. *Order of service for the dedication of the side windows in the Church of St. Michael and All Saints, Basingstoke,* 1971.

Basingstoke, St. Michael and All Saints Church. *Order of service for the unveiling and dedication of the west window 'The Mystery of the Holy Spirit',* 26 May 1988. 5p.

Bertram, Anthony. *Paul Nash: the portrait of an artist.* London, Faber and Faber, 1955. pp.54, 213.

Comfort, Alex. (Introd.) *Cecil Collins: paintings and drawings 1935–45.* Oxford: Counterpoint, 1946, 14p; 25p. of plates.

Drysdale, Helena. *Cecil Collins: 'the quest for paradise'.* Unpublished thesis. Cambridge University, 1982. 42p.

Edinburgh Weavers 1960 Autumn collection [stock catalogue]. [London: Edinburgh Weavers, 1960], pp.20–22, illus.

Evans, Myfanwy. (ed.) *The pavilion: a contemporary collection of British art & architecture.* London: I.T. Publications, 1946, p.63, illus.

Frayling, Christopher. *The Royal College of Art: one hundred and fifty years of art and design.* London: Barrie & Jenkins, 1987. p.106.

Fuller, Peter. *Images of God: the consolations of lost illusions.* London: Chatto & Windus; the Hogarth Press, 1985. pp.101, 103, 124–9, illus. (A Tigerstripe book).

Fuller, Peter. *Theoria: art, and the absence of grace.* London: Chatto & Windus, 1988, p.197.

Gardiner, Wrey. *The dark thorn.* London: Grey Walls Press, 1946. 227p. Passim.

Gardiner, Wrey. *The flowering moment.* London: Grey Walls Press, 1949. pp.30, 41, 56, 69.

Hewison, Robert. *Under siege: literary life in London 1939–45.* London: Weidenfeld and Nicholson, 1977, p.153, illus.

Holtby, Robert T. *Chichester Cathedral.* London: Pitkin Pictorials, c.1986. p.8–9, illus.

Johnstone, William. *Points in time: an autobiography.* Foreword by Michael Culme-Seymour. London: Barrie and Jenkins, 1980, p.216, pp.234–5, 271.

Johnstone, William. *Creative art in Britain: from the earliest times to the present.* London: Macmillan, 1950, p.225, illus.

Johnstone, William. *Creative art in England: from the earliest times to the present.* London: Art Book Club, 1936. pp.196–7, illus.

Lane, John. *The living tree: art and the sacred.* Hartland: Green Books, 1989. pp.123–40, illus.

Lewinski, Jorge. *Portrait of the artist: twenty five years of British art.* Manchester: New York: Carcanet, 1987. p.52. illus.

Lipton, Lawrence. *The holy barbarians.* London: W.H.Allen, 1960, pp.240, 241.

Morton, Jocelyn. *Three generations in a family textile firm.* London: Routledge & Kegan Paul, 1971, Plate 29b.

Raine, Kathleen. *The hollow hill and other poems 1960-1964.* London: Hamish Hamilton, 1965, p. 24. 'Death's country' [after a painting by Cecil Collins].

Raine, Kathleen. *Cecil Collins: painter of paradise.* Ipswich: Golgonooza Press, c.1979. 25p. Reprinted in: *The inner journey of the poet and other papers.*

Raine, Kathleen. *The inner journey of the poet, and other papers.* London: Allen & Unwin, 1982. pp.137–154, illus.

Remy, Michel. *Surrealism in England: towards a dictionary of surrealism in England followed by a chronology.* Nancy: Groupe-Edition Marges, c.1978. p.4.

Read, Herbert (ed.). *Surrealism.* London: Faber, 1937. illus. (pl.21).

Rothenstein, Sir John. *British art since 1900.* London: Phaidon, 1962. pp.170, illus. (pl.104, 105)

Rothenstein, Sir John. *Modern English painters.* Vol.3: Wood to Hockney. London: Macdonald; New York: St. Martins Press, 1974, pp.130-144.

Rothenstein, Sir John. *Modern English painters.* Rev. ed. vol.3, Hennell to Hockney. London: Macdonald, 1984, pp.118–129.

Shone, Richard. *The century of change: British painting since 1900.* Oxford: Phaidon. 1977, pp.27, 28, 34–5, 134–5, 212–13.

Soby, James Thrall. *Contemporary painters.* New York: Museum of Modern Art, c.1948. pp.149–50.

Tate Gallery. *Catalogue of the Print Collection: complete acquisitions to April 1978 with supplement for May 1978 to March 1980.* London: Tate Gallery, 1980. pp.127–8, illus.

Tate Gallery. *The modern British paintings, drawings and sculpture.* Vol.1: A–L/by Mary Chamot, Dennis Farr and Martin Butlin. London: Tate Gallery, 1964. pp.118–120, illus.

Tate Gallery. *The Tate Gallery: report of the Trustees for the year 1 Apr. 1961 to 31 Mar. 1962.* London: HMSO, 1962, p.20, illus.

Tate Gallery. *The Tate Gallery 1970–72 [biennial report].* London: Tate Gallery, 1972. pp.93–95, illus.

Tate Gallery. *The Tate Gallery 1972–74: biennial report and illustrated catalogue of acquisitions.* London: Tate Gallery, 1975. pp.109–110, illus.

Tate Gallery. *The Tate Gallery 1974–76: illustrated catalogue of acquisitions.* London: Tate Gallery, 1978. pp. 82–84, illus.

Tate Gallery. *The Tate Gallery 1980–82: illustrated catalogue of acquisitions.* London: Tate Gallery, 1984. pp.71–72, 241–244, illus.

Tate Gallery. *The Tate Gallery 1984–86: illustrated catalogue of acquisitions including supplement to the catalogue of acquisitions 1982–84.* London: Tate Gallery, 1988. pp.128–30, illus.

Trevelyan, Julian. *Indigo days.* London: Macgibbon & Kee, 1957. pp.61, 129

Wilenski, R.H. *English painting.* New ed. London: Faber & Faber, 1954, p.294, illus.

7 Periodical and newspaper articles

1935

Hugh Gordon Porteus. Art. *New English Weekly*, vol.8, no.2, 24 Oct. 1935, pp.34–5. illus.

1937

Obstacles and art: [review of the exhibition held Dartington, Barn Studio, June–July 1937]. *News of the Day* [Dartington Hall newsletter]. no.794, 22 June 1937, p.2.

Bernard Leach. [Letter]. *News of the Day* [Dartington Hall newsletter], no.795, 25 June 1937, p.3.

Hiram Hague; A Plumber. [Two letters about the exhibition held Dartington, Barn Studio, 1937]. *News of the Day* [Dartington Hall newsletter], no.796, 29 June 1937, p.2.

Harry Walters. [Letter]. *News of the Day* [Dartington Hall newsletter], no.797, 2 July 1937, p.2.

1940

W.G.-B. [W.G.Bosence]. Exhibition of modern art [review of the exhibition organised by Roland Penrose held Dartington, Barn Studio, Mar. 1940]. *News of the Day*: [Dartington Hall newsletter], no.1026, 18 Mar. 1940, pp.2–3.

1941

Sunday evening meeting: The ABC of art: Herbert Read. [Lecture by Read introduced by Cecil Collins]. *News of the Day* [Dartington Hall newsletter], no.1133, 30 May 1941, p.3.

1944

Peter Goffin. Cecil Collins. *Counterpoint*, vol.1 (1944) pp.[2], [15]–[18], illus.

Stephen Spender. The work and opinions of Cecil Collins. *Horizon*, vol.9, no.50, Feb. 1944, pp.115–119, illus.

Maurice Colls. Art: Harry Morley; the Poles; Cecil Collins [review of the 1944 Lefevre exhibition]. *Time and Tide*, 12 Feb. 1944, pp.134–5.

John Piper. Art: the Lefevre Galleries and the Society of Antiquaries. *Spectator*, 18 Feb. 1944, p.147.

H.N.Brailsford. Cecil Collins at the Lefevre [review of 1944 exhibition]. *New Statesman and Nation*, 19 Feb. 1944, p.124.

Art exhibitions. [notice of the 1944 Lefevre exhibition]. *The Times*, 22 Feb. 1944. p.9.

Alex Comfort. Art: Lefevre Galleries [review of the 1944 exhibition]. *New English Weekly*, 9 Mar. 1944. p.177.

Cora Gordon. London commentary: [review of 1944 Lefevre exhibition]. *Studio*, vol.127, May 1944, pp.160–2, illus.

1945

Robin Ironside. Anthology of younger English painters. *Counterpoint*, vol.2, [1945], pp.16–21.

Michael Ayrton. Principal acquisitions of the National Art Collections fund . . . Watercolours and drawings by Cecil Collins and watercolours by Katherine Church at the Lefevre Gallery. *Spectator*, 7 Dec. 1945, p.539.

1946

[Review of Cecil Collins paintings and drawings 1935–45]. *Times Literary Supplement*, 17 Aug. 1946, p.395.

James Thrall Soby. Art in England today. *Saturday Review*, 7 Dec. 1946. pp.76–9.

1947

Gabriel. These foolish things. *Daily Worker*, 9 Oct. 1947, illus.

Divine Folly. *Truth*. 17 Oct. 1947.

1948

Douglas Cooper. 'The Vision of the Fool' by Cecil Collins [book review]. *Burlington Magazine*, vol.90, no.540, Mar.1948, pp.88–9.

Kathleen Raine. 'The Vision of the Fool' by Cecil Collins. *New English Review*, vol.15, no.3, Mar. 1948, pp.283–4.

Cora J. Gordon. London Commentary. *Studio*, vol.135, June 1948, pp.189–90, 191, illus.

1949

Malcolm Ruel. An interesting exhibition 'Modern British Painting' at the Heffer Gallery. *Varsity Supplement*, Oct. 1949, p.6.

John Dexter. Modern British painting 1900–1949. The Heffer Gallery, Cambridge [Review of the exhibition held Oct.–Nov. 1949]. *Art News and Review*, 5 Nov. 1949. vol.1, no.20, p.4.

Art [review of 'Modern British Painting' held Cambridge, Heffer Gallery, Oct.–Nov. 1949]. *Cambridge Review*, vol.71, no.1724, 5 Nov. 1949, pp.110–112.

Bryan Robertson. Cecil Collins. Portrait of the artist, no.22. *Art News and Review*, vol.1, no.22, 3 Dec. 1949, p.1, illus.

1950

Three modern painters [review of the group exhibition held Cambridge, Heffer Gallery, Jan.–Feb. 1950]. *Varsity*, 21 Jan. 1950, p.12.

Carol Hogben. Cecil Collins, Merlyn Evans, Francis Rose. Heffers, Cambridge [review of the exhibition held Jan.–Feb. 1950]. *Art News and Review*, 28 Jan. 1950, vol. 1, no. 26, p.5.

Bernard Denvir. Recent tapestries: Arts Council Gallery, 4 St James's Square. *Art News and Review*, 28 Jan. 1950, vol.1, no.26, p.5.

John Curtis. Art: three Cambridge galleries. *Varsity Supplement*, Feb. 1950, p.15.

Carol Hogben. Art: The Heffer Galleries. [review of the exhibition held Cambridge, Heffer Gallery, Jan.–Feb. 1950]. *Cambridge Review*, vol.71, no.1731, 4 Feb. 1950, p.298.

Carol Hogben. Art: The Heffer Gallery. [review of the exhibition held Cambridge, Heffer Gallery, Feb. 1950]. *Cambridge Review*, vol. 71, no.1734, 25 Feb. 1950, p.370.

M.W.L.K. Art-Thelma Hulbert-Heffers. *Varsity*, 22 Apr. 1950, p.7.

Carol Hogben. Art: The Heffer Galleries [review of recent paintings by Thelma Hulbert and new lithographs by English artists, Apr.–May 1950]. *Cambridge Review*, vol.71, no.1738, 29 Apr. 1950, pp.468–9.

Carol Hogben. Thelma Hulbert: English lithographs Heffer's Cambridge. *Art News and Review*, 20 May 1950, vol.2, no.8, p.5.

M.B.N.R. [Martin Richardson]. Art: Cambridge Drawing Society – Guildhall. *Varsity*, 20 May 1950, p.7.

William Gaunt. On the slopes of Parnassus 1 – Cecil Collins. *World Review*, n.s. no.19, Sept. 1950, pp.29–32, [4]p. of plates.

Martin Richardson. At the galleries: watercolours. *Varsity*, 28 Oct. 1950, p.9.

1951

Christopher Layton. Art in Cambridge: European influence on our painting [review of the exhibition held Cambridge, Heffer Gallery, Feb. 1951]. *Varsity*, 24 Feb. 1951, p.6, illus.

R.J.M. [Richard Mayne] Art [review of exhibition held Cambridge, Heffer Gallery, Apr.–May. 1951]. *Cambridge Review*, vol. 72, no.1762, 28 Apr. 1951, pp.460–462.

1952

Peter Gray. Heffer's Gallery exhibition of graphic art [review of the exhibition held Apr.–May 1952]. *Varsity*, 3 May 1952, p.9.

Anne Peter, A.U. Chapman. Art: in sickness and in health [review of Arts Council exhibition '4 contemporaries' held Cambridge, All Saints Passage, 1952]. *Cambridge Review*, vol.73, no.1790, 24 May 1952, pp.519–20.

Bryan Robertson. The New Burlington Galleries [review of the AIA exhibition held Dec. 1952]. *Art News and Review*, vol.4, no.24, 27 Dec. 1952, p.4.

1953

A.U. Chapman. Art: the Heffer Gallery [review of the exhibition held Jan.-Feb. 1953]. *Cambridge Review*, vol.74, no.1803, 31 Jan. 1953, p.272.

1954

Anthony Bertram. Cecil Collins. *Studio* vol.147, Jan. 1954, pp.20-23, illus.

1955

W.J. Strachan. Contemporary tapestries from France and Britain. *Studio*, vol.150, no. 753, Dec. 1955, pp.161-169, illus.

1956

Jane Stockwood. Above the cloud. *Harper's Bazaar*, Jan. 1956, p.59, illus.

Patrick Hayman. Cecil Collins: a visionary painter [review of the exhibition held Leicester Galleries, Feb. 1956]. *Art*, vol.2, no.7, 16 Feb. 1956, p.6.

Bryan Robertson. Cecil Collins and Terry Frost [review of the exhib. held Leicester Galleries, Feb. 1956]. *Art News and Review*, vol.8, no.2, 18 Feb. 1956, p.4, illus.

Graham Hughes. Woven quality [review of the Edinburgh Weavers exhibition held London, Mount Street Showroom]. *Art News and Review*, vol.8, no.2, 18 Feb. 1956, p.6, illus.

Irene Nicholson. Cecil Collins y el loco: carta de Inglaterra *Universidad de Mexico*, vol.10, no.12, Aug. 1956, pp.22-3, illus.

1958

Kathleen Raine. Cecil Collins: a platonic painter. *Painter and Sculptor*, vol.1, no.1, Spring 1958, pp.24-6, illus.

Pierre Rouve. Textile phoenix [review of the 1958 Gimpel Fils exhibition]. *Art News and Review*, vol.10, no.23, 22 Nov. 1958, pp.12, 18.

1959

Eric Newton. Translations of a private myth. *Guardian*, 28 Nov. 1959, p.5.

Nevile Wallis. At the galleries [review of the exhib. held London, Whitechapel 1959]. *Observer*, 29 Nov. 1959, p.15.

*Gothic fantasy: [review of the exhib. held London, Whitechapel 1959]. *Evening Standard*, 30 Nov. 1959.

Pierre Jeannerat. This so English artist joins our outsiders [review of the 1959 Whitechapel Exhibition]. *Daily Mail*, 2 Dec. 1959, p.5.

Restricted vision: the art of Mr Cecil Collins/from our art critic [review of the 1959 Whitechapel exhibition]. *The Times*, 4 Dec. 1959, p.15, illus.

James Burr. Cecil Collins: Whitechapel Art Gallery [review]. *Art News and Review*, 5 Dec. 1959, p.6, illus.

Eric Newton. Art: Cecil Collins. [review of Whitechapel exhibition]. *Time & Tide*, 5 Dec. 1959, p.134, not illus.

[Review of the 1959 Whitechapel exhibition]. *Jewish Chronicle*, 11 Dec. 1959, p.43.

John Russell. Teller of tales [review of 1959 Whitechapel exhibition]. *Sunday Times*, 13 Dec. 1959, p.24.

R.G.B. [Richard Burnett] By the way [review of the 1959 Whitechapel exhibition]. *Methodist Recorder*, 17 Dec. 1959, p.6.

Simon Hodgson. Art [review of the 1959 Whitechapel exhibition]. *Spectator*, 18 Dec. 1959, p.910.

Iris Conlay. Angels dance in Whitechapel [review of the 1959 exhibition]. *Catholic Herald*, 24 Dec. 1959, p.4.

1960

F.E.H. The Art of Cecil Collins [review of the 1959 Whitechapel exhibition]. *Methodist Recorder*, 7 Jan. 1960.

G.S. Whittet. London commentary [review of the 1959 Whitechapel exhibition]. *Studio*, vol.159, no.803, Mar. 1960, p.101.

James Burr. A new gallery [review of the 1960 ABC Gallery exhibition]. *Art News and Review*, vol.12, no.9, 21 May 1960, p.8.

R.H. Wilenski. Something to be said for aesthetic art. *Studio*, vol.159, June 1960, cover; pp.191-195, illus.

Patrick Reyntiens. An exhibition in retrospect [review of the Guild of Catholic Artists' and Craftsmen's exhibition]. *Tablet*, 17 Dec. 1960.

Kenelm Foster. Cambridge pictures [review of the Society of Painters and Sculptors annual exhibition held Cambridge, Arts Council Gallery, 1960]. *Tablet*, 24 Dec. 1960.

1961

Nevile Wallis. The painter in print. *Observer*, 13 Aug. 1961.

[Review of the exhibition held Athens, Zygos Gallery]. *Zygos Magazine*, no.70, Sept. 1961, p.40. Greek text.

1962

John Rothenstein. Choosing art. *Viewpoint*, no.1, 1962, pp.4-9, illus.

1963

Anton Ehrenzweig. The new academy. *Athene*, vol.10, no.4, Spring 1963, pp.7-9.

1965

James Burr. London Galleries: beyond earthly horizons [review of the 1965 Tooth Gallery exhibition]. *Apollo*, vol.81, Feb. 1965, p.150, 151, illus.

The Dark Landscape [reproduction of work in the 1965 Tooth Gallery exhibition]. *Studio International*, vol.169, no.862, Feb. 1965, p.[v], illus.

Nevile Wallis. Art: the visionary Collins. *Spectator*, 5 Mar. 1965 p.298.

G.S. Whittet. Pop, op and now return to fig: London commentary [review of the 1965 Tooth Gallery exhibition]. *Studio International*, vol.169, no.864, Apr. 1965, p.176, illus.

1966

On exhibition: [reproduction of work in the exhibition held Chilham, Canterbury, Robins Croft, Nov.-Dec. 1966]. *Studio International*, Nov. 1966, vol. 172, no.883, p.265, illus.

1970

Robin Skelton. The vision of Cecil Collins. *The Malahat Review*, no.13, Jan. 1970, pp.56-80, illus.

*—— Masters of tomorrow. *Accent on Good Living*, no.1, Mar. 1970, pp.42-5.

1971

James Burr. London galleries [review of the 1971 Tooth Gallery exhibition]. *Apollo*, vol.94, Sept. 1971, pp.239-240, illus.

A. Causey. A highly individual talent. *Illustrated London News*, Sept. 1971, p.63, illus.

Michael Shepherd. Cecil Collins [review of 1971 Tooth Gallery exhibition]. *Arts Review*, vol. 23, no.19, 25 Sept. 1971, p.570, illus.

William Packer. London [review of the exhib. held Arthur Tooth's Sept.-Oct. 1971]. *Art and Artists*, vol.6, no.6, Oct. 1971, p.49, illus.

Bernard Denvir. London letter [review of the 1971 Tooth Gallery exhibition]. *Art International*, vol.15, no.9, Nov. 1971, pp.67-70.

1972

Hector E. Ciocchini. La pintura de Cecil Collins. *Cuaderno de Filosofía/Universidad de Buenos Aires*, Ano 12, no.18, Jul.-Dec. 1972, pp.273-8.

William Packer. London [review of the exhib. held London, Hamet Gallery]. *Art and Artists*, vol.7, no.9, Dec. 1972, p.44, illus.

1973

William Feaver. London letter [review of the 1972 Hamet Gallery exhibition]. *Art International*, vol.17, no.1, Jan.1973, pp. 29-33, illus.

James Burr. Round the galleries. [review of the altarpiece for Chichester Cathedral]. *Apollo*, vol. 98, Nov. 1973, pp.394-5, illus.

1974

Patrick Reyntiens. Icon of divine light. *The Tablet*, 27 July 1974, p.729, illus.

1975

Norman Adams . . . [et al.]. Artists: age shall not weary them [letter to the editor protesting about the proposed enforced retirement of Cecil Collins from the Central School of Art]. *Guardian*, 15 Mar. 1975, p.10.

Jane Phillips, Michael Pattrick. When do artists lay down the brush? [reply to the letter of 15 Mar. 1975]. *Guardian*, 25 Mar. 1975.

Ken Rowat. Age and the art transplant [letter about retirement in art schools]. *Guardian*, 5 Apr. 1975.

1976

Martina Margetts. Stephen Tennant, Cecil Collins [review of exhib. held] 24 June-23 July 1976, Anthony d'Offay. *Connoisseur*, vol.192, no.772, June 1976, p.243, illus.

James Burr. Round the galleries [review of the 1976 d'Offay exhibition]. *Apollo*, vol. 104, no. 173, July 1976, p.69, illus.

Richard Shone. Cecil Collins, Stephen Tennant. [review of the 1976 d'Offay exhib.]. *Arts Review*, vol.28, no.14, 9 July 1976, p.351, illus.

William Feaver. A saintly fool. *Observer* [Review Section], 18 July 1976, p.20, illus.

Richard Morphet. Cecil Collins, Anthony d'Offay Gallery, 24 June-23 July 1976. *Studio International*, vol.193, no.983, Sept.-Oct. 1976, pp.214-215, illus.

Richard Shone. The eye of the heart: the work of Cecil Collins (Arts Council film). *Burlington Magazine*, vol.120, Dec. 1978, p.870.

1979

Keith Walker. Reflections on Cecil Collins. 'The Crucifixion'. *New Fire*, vol.5, no.38, Spring 1979, pp.266-70, illus.

*P.L.Travers. The youngest brother. *Parabola: Myth and the Quest for Meaning*, vol.4, no.1, Feb. 1979, pp.38-43.

Andy Christian. The realm where fools are wise. *Christian Science Monitor*, 6 June 1979, p.20, illus.

1981

Brian Keeble. Theatre of the soul: a conversation with the artist Cecil Collins. *Temenos*, no.1 1981, pp.59-85, illus.

Angel (1977). *Times Literary Supplement*, 31 July 1981, p.876, illus.

Guy Burn. Cecil Collins [review of the 1981 Tate Gallery exhibition]. *Arts Review*, vol.33, nos.16 & 17, 14 & 28 Aug. 1981, p.360, illus.

John Russell Taylor. Galleries: Cecil Collins [review of the 1981 Tooth Gallery exhibition]. *The Times*, 8 Sept. 1981, p.8.

Janet Watts. A portrait of the artist and his worldly dealer. *Observer* [Review Section], 1 Nov. 1981, p.26, illus.

Christopher Andreae. Assurance in a colossal vision. *Christian Science Monitor*, 19 Nov. 1981, p.28, illus.

1982

Edward Lucie-Smith. Letter from the United Kingdom [review of the 1982 d'Offay exhib.]. *Art International*, vol. 25, nos.3-4, Mar./Apr. 1982, pp.78-9.

Iain McGilchrist. Not quite immaterial: Kathleen Raine 'The Inner Journey of the Poet'. *Times Literary Supplement*, 22 Oct. 1982, p.1148.

1983

Helena Drysdale. Portrait of Cecil Collins. *Matrix*, no.16, Spring 1983, pp.4-5, illus.

James Burr. From iron into flesh [review of the 1983 Plymouth exhibition]. *Apollo*, vol.118, no.261, Nov. 1983, p.450, illus.

Roger Malone. City tribute to artist [review of the 1983 Plymouth exhibition]. *Western Morning News*, 7 Nov. 1983, illus.

Marina Vaizey. In view: Collins at Plymouth. *Art and Artists*, no.207, Dec. 1983, p.4, illus.

Peter Fuller. Cecil Collins [review of the 1983 Plymouth exhibition]. *Art Monthly*, no.72, Dec. 1983, p.14.

1984

The Divine Land (1979). *Art and Artists*, no.215, Aug. 1984, p.33, illus.

1985

Brian Morton. 'Fools' paradise. *Times Higher Education Supplement*, 6 Sept. 1985, p.12.

1986

Philip Vann. The poets vision. *The Artist*, vol.101, no.1, Jan. 1986, cover, pp.4-7, illus.

1987

John Piper. Art: the Lefevre Galleries and the Society of Antiquaries [review of the Lefevre exhibition]. *Spectator*, 18 Feb. 1987, p.147.

Georgina Howell. The fine art of politics: six ex students recall their RCA days [review of Royal College of Art exhibition]. *Sunday Times Magazine*, 20 Mar. 1988, pp. 44-51, illus.

Marina Vaizey. The quest for paradise. [review of the Barbican exhibition]. *Sunday Times*, 24 May 1987, p.47, illus.

Paddy Kitchen. Posterity then and now [review of the 1987 Barbican exhibition. *Country Life*, 28 May 1987, pp. 134-5, illus.

John Lane. Cecil Collins: to the gates of the sun. *Resurgence*, no.122, May-June 1987, cover, pp.12-15, illus.

John Lane. In search of sacred painting. *Resurgence*, no.122, May-June 1987. pp.16-19.

Bernard Denvir. A paradise lost: neo-romanticism in Britain 1935-55 [review of the 1987 Barbican exhibition]. *The Artist*, July 1987, cover, pp.16-18, illus.

Peter Fuller. London, Barbican Art Gallery, the neo romantics [review]. *Burlington Magazine*, 129, Jul. 1987, pp. 472-4.

Angela Summerfield. Neo romantics [review of the 1987 Barbican exhibition]. *Apollo*, vol.126, Aug. 1987, p.120, illus.

Philip Vann. A paradise lost [review of the 1987 Barbican exhibition]. *Contemporary Review*, 251, 25 Aug. 1987, pp.97-101.

William Anderson. A view of paradise. *Resurgence*, no.124, Sept.-Oct. 1987, pp.20-21.

1988

Mike Englefield. Mystery of the holy spirit. *[Basingstoke] Gazette*, 27 May 1988, p.4, illus.

[Review of the 1988 d'Offay exhibition]. *Evening Standard*, 31 May 1988, p.6.

William Anderson. Cecil Collins and the singing sea. *Resurgence*, no.128, May-Jun. 1988, cover, pp.28-31, illus.

Tim Hilton. Strong show of odd hands: critics choices: art/dance. *Guardian*, 1 June 1988, p.37, illus.

Arthur Attwood. Joyful dedication of a work of art [review of the unveiling of 'The Mystery of the Holy Spirit' Basingstoke]. *[Basingstoke] Gazette*, 3 June 1988, illus.

Patrick Reyntiens. Galleries [review of the d'Offay exhibition, June 1988]. *The Tablet*, 11 June 1988, p.681.

William Feaver. Cecil Collins reviewed [review of the 1988 d'Offay exhibition and the unveiling of 'The Mystery of the Holy Spirit' Basingstoke]. *Observer*, 12 June 1988, p.39.

John Russell Taylor. According to Collins [review of the 1988 d'Offay exhibition]. *The Times*, 14 June 1988, p.12, illus.

Mary Rose Beaumont. Cecil Collins [review of the 1988 d'Offay exhibition]. *Arts Review*, 17 June 1988, p.420.

Giles Auty. Country roots [review of the d'Offay exhibition]. *Spectator*, 18 June 1988, pp.39–40.

Brian Keeble. Cecil Collins. *Modern Painters*, vol.1, no.2, Summer 1988, pp.65–6, illus.

Margaret Garlake. The spirit of place. *Art Monthly*, no.118, Jul.–Aug. 1988, pp.29–31.

Giles Auty. The great happiness: the paradise we come from [review of 'Cecil Collins: The quest for the great happiness', by William Anderson]. *Spectator*, 13 Aug. 1988, p.33, illus.

Francis Spalding. Cecil Collins: The quest for the great happiness by William Anderson [book review]. *Burlington Magazine*, vol.130, Sept. 1988, p.709.

Andrew Lambirth. Cecil Collins: the world of the heart. *Artist's and Illustrator's Magazine*, no.24, Sept. 1988, pp.12–15, illus.

Merlin James. Art: doubts [review of 'Cecil Collins: The quest for the great happiness',/by William Anderson]. *London Magazine*, n.s., vol.28, no's.7–8, Oct.–Nov. 1988, pp.103–110, illus.

Michael Shepherd. The world seen with delight [review of William Anderson's monograph] *Sunday Telegraph*, 11 Dec. 1988, p.20, illus.

1989

Richard Dorment. Great exhibitions of the year ahead. *Daily Telegraph*, 2 Jan. 1989, p.11.

And the Light shineth in the darkness; and the darkness comprehended it not.
And this is the condemnation, that Men loved darkness rather than light.

The Gospel according to St. John
Chapter 1, v.5 and Chapter 3, v.19

Lenders

David Batterham 138
Collection of Peter Bowles 27, 60, 98
Sir Michael Culme-Seymour 21, 92
Dartington Hall Trust 23, 75, 86, 91, 95, 135, 143
Derby Art Gallery 109
Anthony d'Offay Gallery, London 64, 65
Mary Fedden 20
Kirklees Metropolitan Council, Huddersfield Art Gallery 108
Leeds City Art Galleries 32
Bryce McKenzie-Smith 40, 52, 118
Peter Nahum Gallery 22, 93
David Orr 94
Private Collection 1, 2, 3, 4, 6, 7, 8, 9, 11, 12, 14, 15, 16, 17, 18, 19, 25, 26,
 28, 29, 30, 31, 34, 35, 36, 37, 38, 39, 41, 42, 43, 44, 45, 46, 47, 48, 50, 51,
 53, 54, 55, 56, 59, 61, 63, 66, 67, 68, 69, 70, 71, 72, 73, 74, 76, 77, 78, 79,
 80, 81, 82, 83, 84, 85, 87, 88, 89, 96, 97, 99, 100, 101, 102, 103, 104, 105,
 106, 110, 111, 112, 113, 114, 115, 116, 117, 119, 120, 121, 122, 123, 124,
 125, 126, 127, 128, 129, 130, 131, 132, 133, 134, 136, 137, 140, 142, 144,
 145, 146, 147
Jonathan Stedall 139
Tate Gallery 5, 10, 24, 33, 49, 90, 141,
Board of Trustees of the Victoria and Albert Museum, London 107
Mr and Mrs Thomas E. Worrell, Jr 13, 57, 58, 62